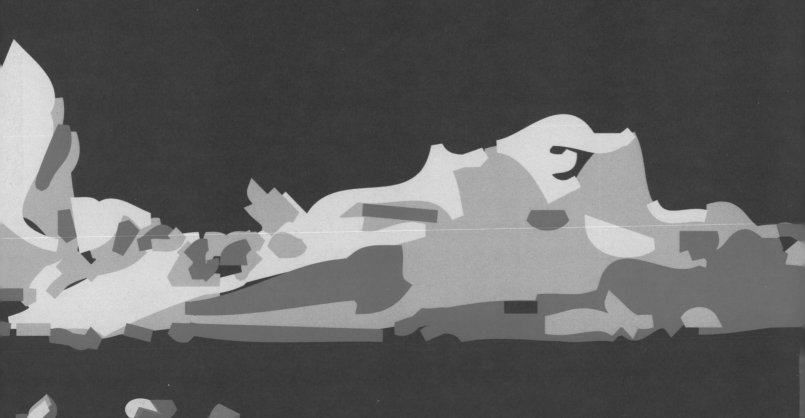

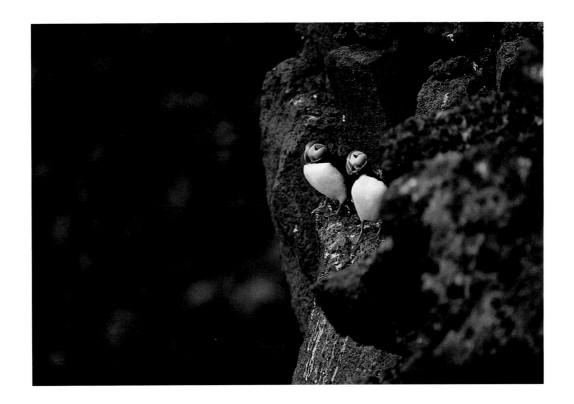

Journey through

ICELAND

Photos by

Max Galli

Text by

Ernst-Otto Luthardt

Stürtz

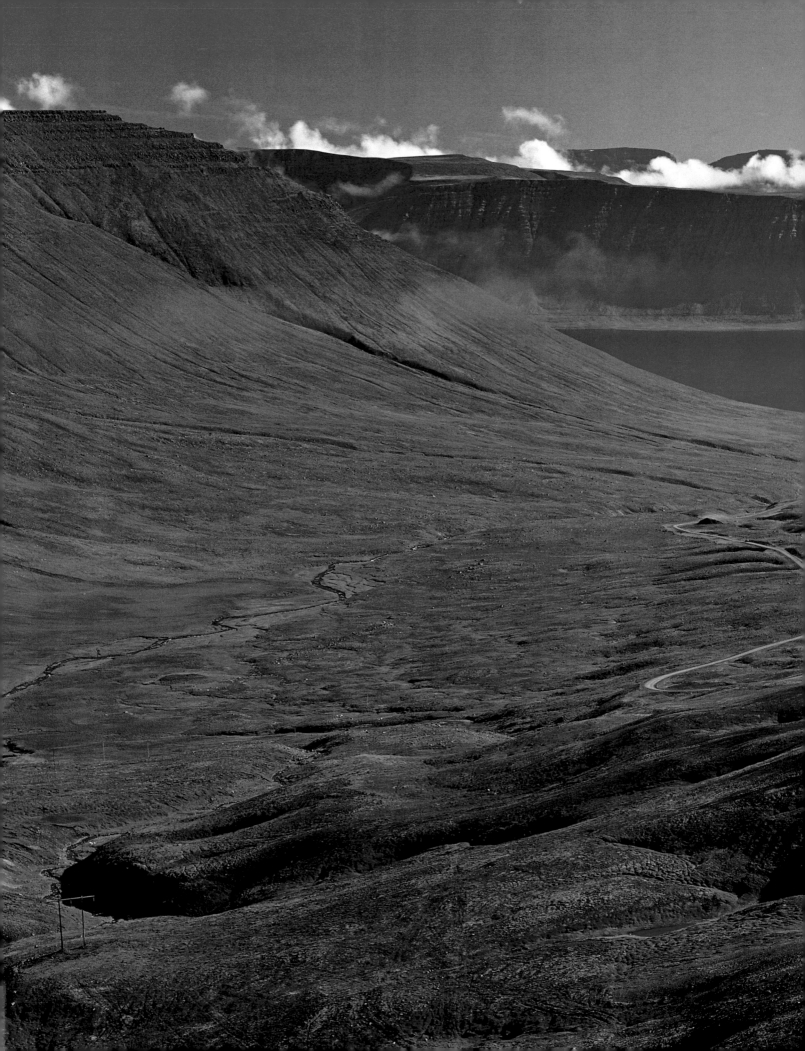

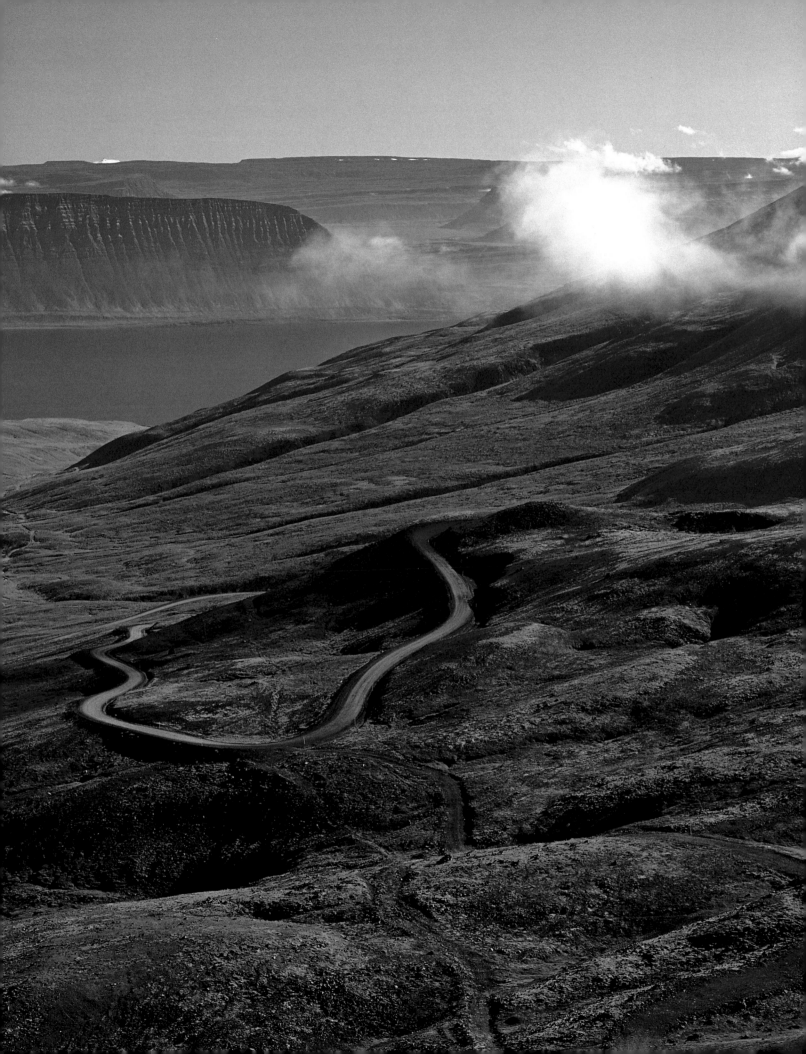

CONTENTS

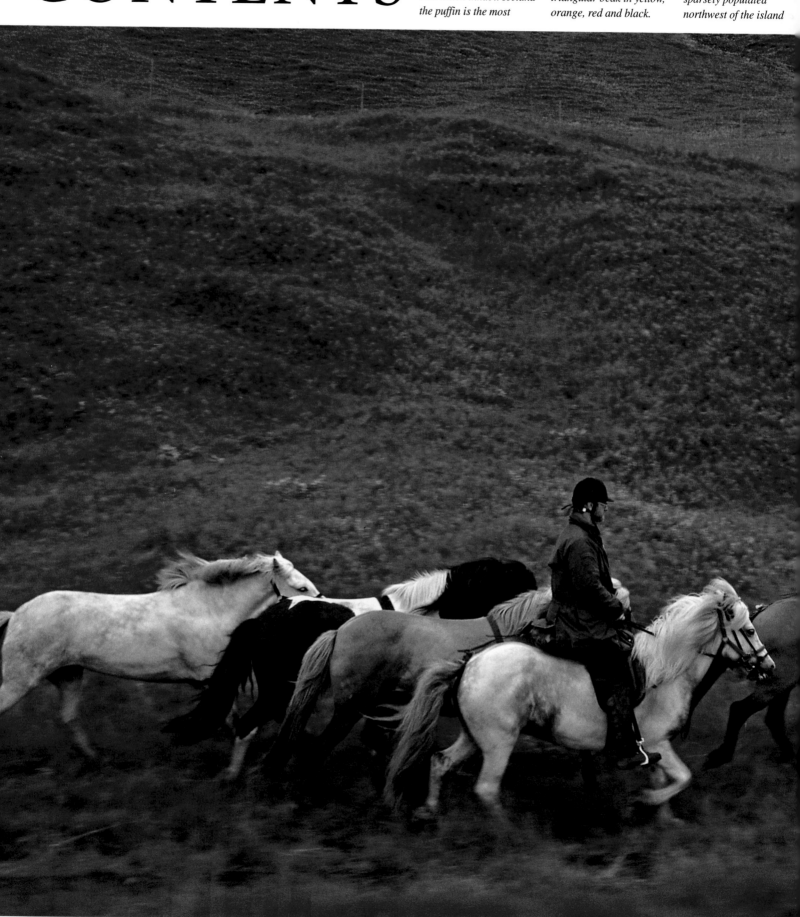

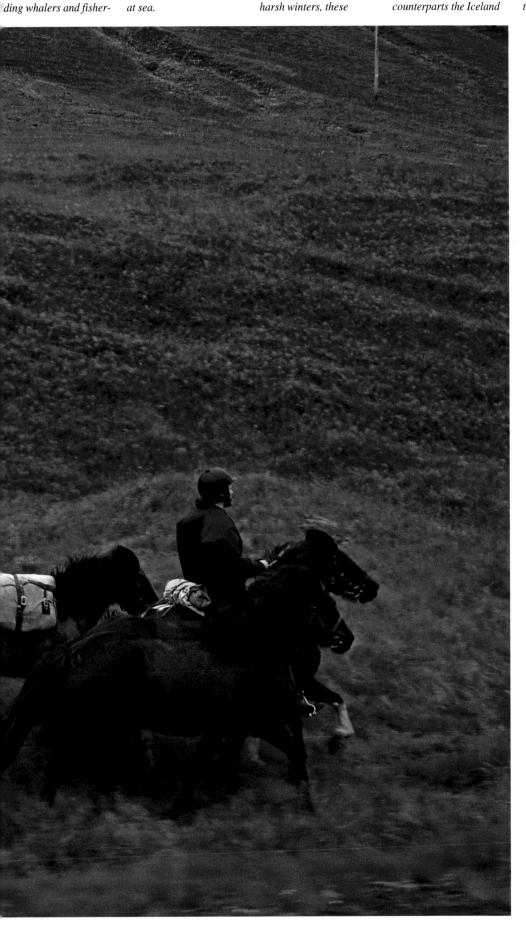

tween Hrafnseyri und
ingeyri. The latter has a
ng history, once pro-
ding whalers and fisher-

men from Europe and
America with a welcome
refuge after long journeys
at sea.

Below:
Easy to look after and
able to endure Iceland's
harsh winters, these

miniature horses are used
for both pleasure and
work. Unlike its larger
counterparts the Iceland

pony can also pace and
do a running walk called
the tolt.

Page 10/11:
The Goðafoss was named
a thousand years ago
after the images of
heathen gods hurled into
its torrential rapids.
Today the twin waterfall
in the north of the country
is one of the most popular
attractions in Iceland.

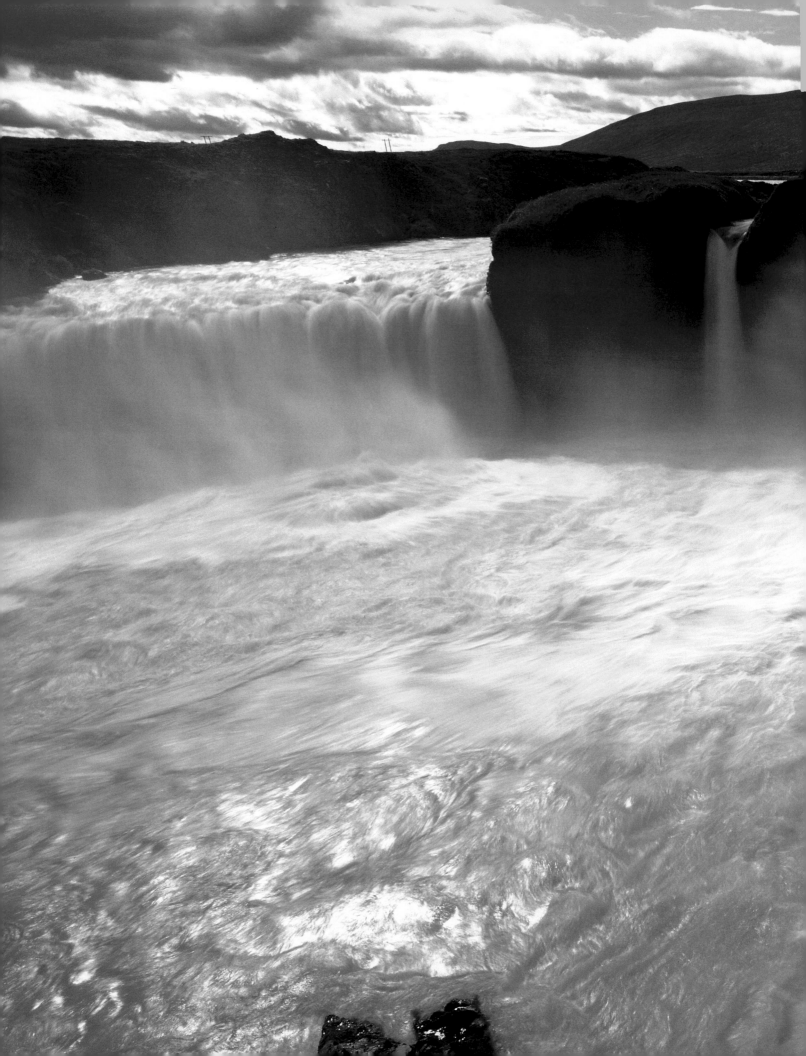

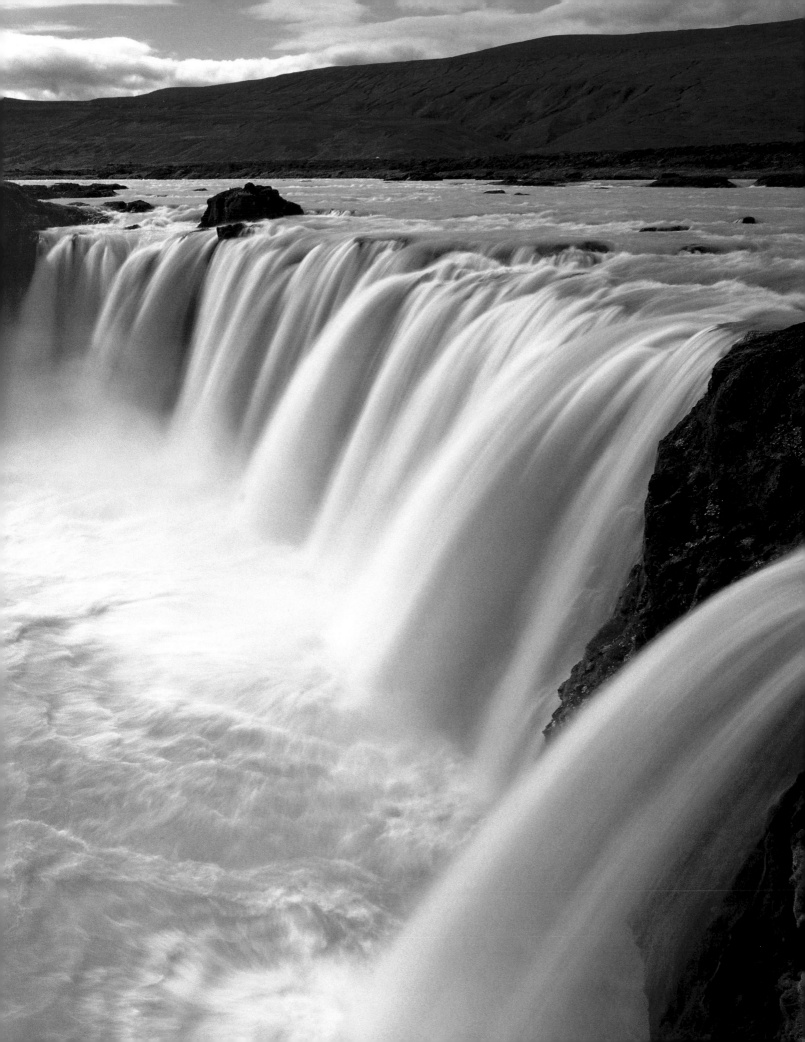

ICELAND –

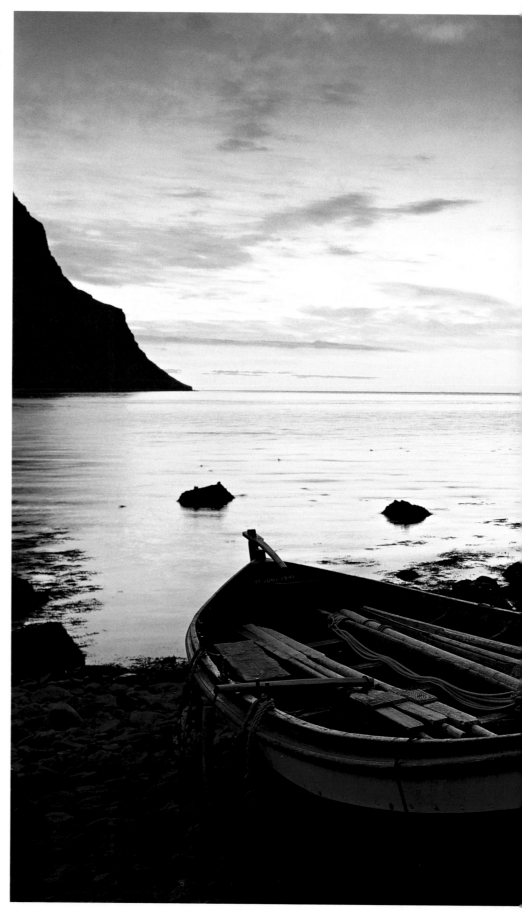

Evening light over Bolungarvík, the most northerly and also the oldest settlement in the Westfjords. The 100-year-old Ósvör fishery, recently restored, is well worth visiting, the museum a stark reminder of the hardships the villagers once had to endure.

Money may not be able to buy you love, but it could buy you a holiday in Iceland – providing you've got lots of it. Iceland, with all its dazzling natural attractions, does not come cheap. The cost of alcohol is extortionate. Trying to find a restaurant in Reykjavík serving food at a reasonable price is like looking for a needle in a haystack; elsewhere, don't even bother to try. The holiday season in Iceland is also relatively short; June, July and August are the best times to travel. If you miscalculate somewhat and end up here in May or September, be prepared for frost at night. In the highlands temperatures plunge below zero all year round. Souvenirs? Your standard-issue, itchy fisherman's jumper – which you bought in Norway – lies neatly folded and unworn in the wardrobe. Stones, minerals? They're too heavy for your suitcase, even though you've probably never seen colours like them before. No, Iceland is definitely not the ideal tourist destination – and never will be.

»Thank goodness for that!« cry the 150,000 who – despite or perhaps because of this – are drawn to the island year in year out. This is the one place they are guaranteed raw natural beauty and magnificent unspoilt scenery otherwise not found on our European Continent. The juxtaposition of gigantic glaciers and smouldering volcanoes, of eternal ice and steaming hot springs, of monotonous deserts of lava and volcanic debris and green mossy valleys, of countless waterfalls and long stretches of jagged and sandy coastline, is so incredibly grand that mere words cannot possibly do it justice. Halldór Laxness, the great Icelandic novelist and Nobel Prize winner, once wrote that in his country you could still feel the earth turning, feel it breathing.

A NATURAL PARADISE

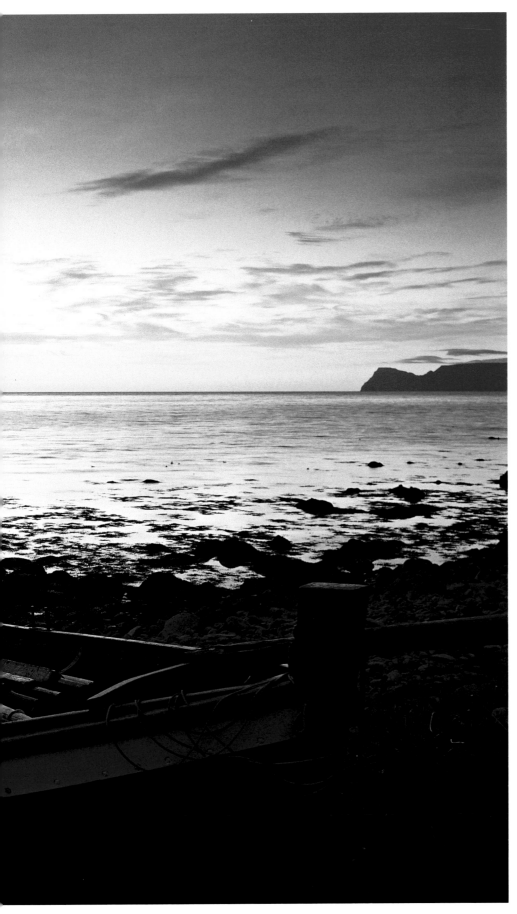

A LENGTHY EVOLUTION

20 million years ago Iceland is thought to have risen up out of the Atlantic. Although many, many years have passed since then, Iceland is still evolving. The country is still growing. Tons of sand hollowed out of the rock by glaciers are washed down to the coast by the many rivers, gradually expanding the shoreline; the fiery elements well below the earth's crust play an even more important role in the remodelling of Iceland. Vestmannaeyjar (the Westman Islands) in the south, for example, is in a particularly active volcanic region. On older maps the island of Surtsey is missing; it suddenly appeared above the waves in 1963. Ten years later, on a dark night in January, the ground split open on the main island of Heimaey and a new volcano catapulted ash and lava into the winter sky. When it finally ceased erupting six months later the land had grown two square kilometres (two-thirds of a square mile) in size. Many homes were destroyed, but thankfully no lives were lost. The main fishing harbour was also spared – thanks to the engineering genius of the quick-witted islanders. When the molten streams of lava threatened to cut off the main access to the harbour, they pitted it against the Atlantic, hosing it down with sea water and bringing the volcanic mass to a solidified halt.

The first man to set foot on the island and erect a home on the turbulent soil is said to be the Viking Garðar Svárvarsson. The little town of Húsavík in the north celebrates this event with both its name (»house bay«) and an annual festival commemorating 870, the year of Svárvarsson's alleged arrival. As the valiant seaman failed to remain here long he missed his chance to go down in the annals of history as the first inhabitant of Iceland. This great honour was bestowed upon Ingólfur Arnarson who postdated Svárvarsson by two years – and stayed. Many of the 20,000 to 30,000 who followed him over the next few decades came from the west of Norway and the British Isles.

A mighty tome known as the »Landnáma-bók« lists the names and properties of several hundred of these immigrants. Although the original has been lost, three later versions from the 13th century have survived, providing us with information on the names and lives of approximately 430 families. Drawing up genealogies is still one of the favourite pastimes of the people of Iceland. The island's remote location, the relatively small number of inhabitants and a language which has barely changed in over one thousand years enable people to trace their family trees back to practically the year dot and feel they are related to almost all of their

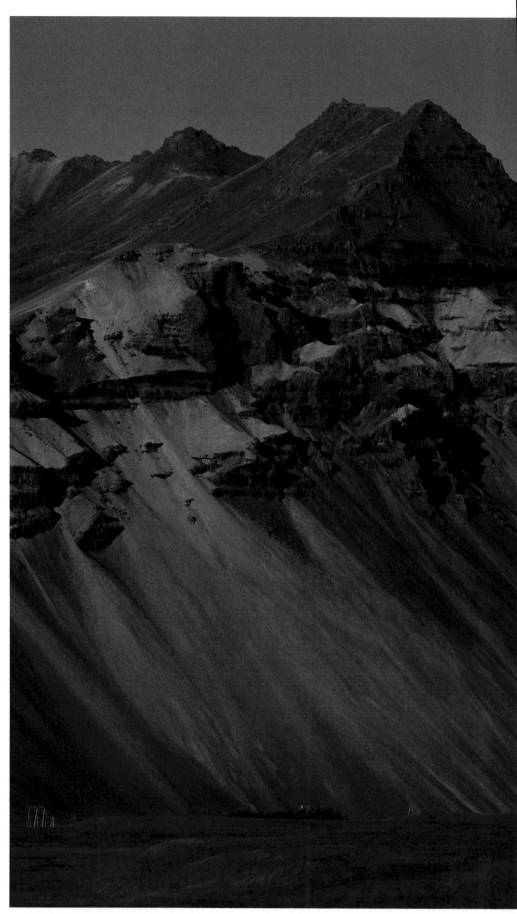

fellow countrymen. The Icelanders are thus well up on their family history and – through the many Old Icelandic sagas which have passed down the generations – also national history, a fact they are known to be very proud of.

An early high point in Iceland's history is the year 930, when the Alþing heralded the dawn of the first parliamentary system. At the first sitting of this national assembly in midsummer the heads of the island's most powerful families met to discuss problems and disputes. These restless seafarers of yore may have seen the island as their mother ship, a base from which to embark on new journeys into the unknown. In 982 they reached Greenland and at the turn of the first millennium AD sailed to North America. For many years the latter discovery was pooh-poohed by the academic world; this was mere wishful thinking, a patriotic, northern claim to fame. This all changed in the 1960s when the L'Anse Aux Meadows Viking settlement was discovered in Newfoundland. Like Heinrich Schliemann with his Homer a hundred years before him, Norwegian Helge Ingstad simply took the words of an ancient saga literally and set about determining their validity. He based his research on the legendary tales written down in the 12th and 13th centuries which related the mythological and authentic history of the north. Their authors were both poets and historians. When the most famous of them, Snorri Sturluson, died in 1241 a great epoch came to an end. The Icelanders peacefully submitted to rule under Norway. Sovereignty passed to the Danes in 1380 and lasted for almost 700 years.

The often bemoaned geographical isolation of Iceland mirrored its political status. Long untouched by goings-on in Central Europe, the violent initiation of the Reformation from 1540 to 1550, the ban on all trade with states other than Denmark in 1602 and the English merchants' putsch of 1809, which resulted in Danish adventurer Jørgen Jørgensen ruling as king of Iceland for 100 days, were the most significant political events in centuries. The plague of 1402 to 1404, which claimed the lives of two thirds of the population, further epidemics at the beginning and end of the 18th century and a number of devastating volcanic eruptions made far deeper incisions in the evolution of the Icelanders. In the wake of these natural catastrophes just 40,000 were left on the island,

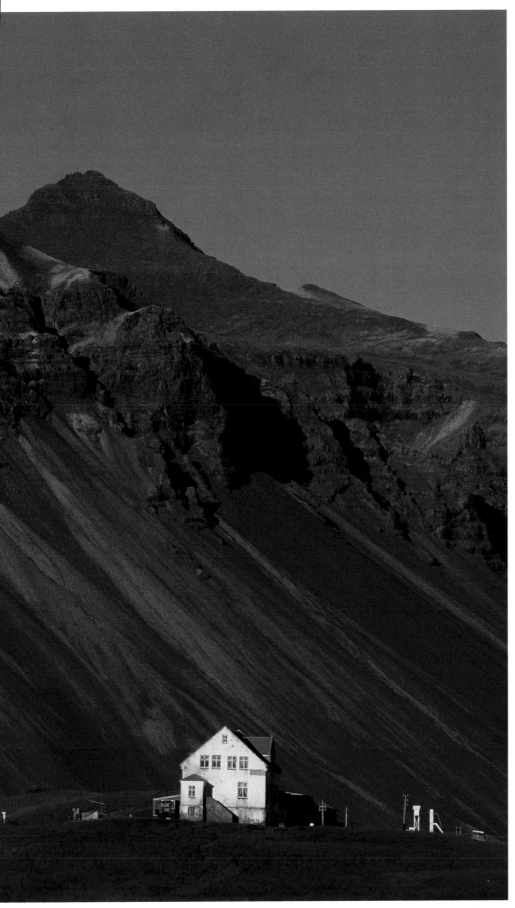

prompting the Danish court to seriously consider abandoning the country altogether and moving the sorry rest of the population to Jutland.

Yet by the mid-19th century both the population and their sense of national identity had gone from strength to strength. In 1843 the Alþing was reborn – albeit in a purely advisory role – and various moves towards independence were made. Once the Danes finally agreed to hand most of the government of their northern territory over to the Icelanders in 1918, the rest was easy; in true Viking style Iceland declared its national independence in 1944 while the Danish »motherland« was otherwise occupied – namely by the Germans during the Second World War.

Since then both the country and its people have experienced much change. Iceland's system of agriculture, unaltered for centuries, has finally been modernised; industry has undergone a radical transformation with the introduction of progressive and alternative forms of energy, such as geothermal and hydroelectric power. Ca. 50 kilometres (30 miles) from Reykjavík, for example, a team of practically-minded, innovative engineers has constructed an earthly glass paradise, an enormous greenhouse complex fuelled by Iceland's rich natural resources. The small commune of Hveragerði is now the garden of Iceland, where bananas and oranges thrive. The driving force behind the project is economy; here Iceland can grow its own fruit and vegetables for a fraction of the price it would cost to import them in winter. And that's not all. The experts in their glass houses have a dream. One day they hope to populate the practically treeless island with their own cultivated seedlings.

Iceland has also made the headlines in the field of politics. Traditionally a man's world, 1980 saw the first woman president take up office. Literary scholar and drama expert Vigdís Finnbogadóttir was also the woman who instigated the famous meeting between Reagan and Gorbachov in her native city of Reykjavík in 1986, heralding the beginning of the end of the Cold War. This is, after all, the land which has spent centuries reconciling fire and ice ...

REYKJAVÍK – A MINIATURE METROPOLIS IN A GRAND ENVIRONMENT

Where Iceland (with the exception of the island of Grímsey) is still struggling to enter the Arctic Circle, the capital of Reykjavík has long

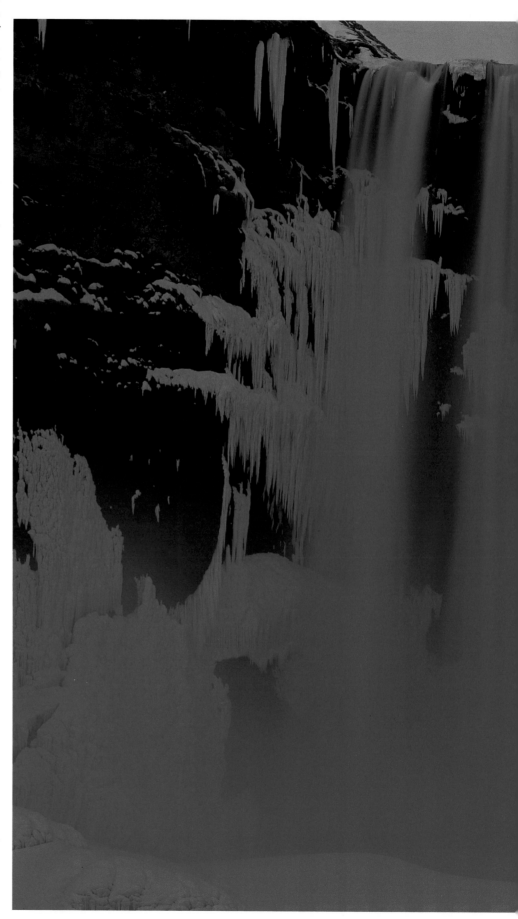

*60 metres (ca. 200 feet)
high, Skógafoss on the
south coast is one of
the tallest waterfalls on
the island. Legend has
it that here be buried
treasure, hidden here
by the first settlers.*

exceeded its target of 100,000 inhabitants. Today over half of the population live here.

For the visitors who enter Iceland at the neighbouring airport of Keflavík, the capital is their first port of call. Most of its prestigious buildings from the first half of the 20th century – such as the National Theatre and Icelandic National Library – hover somewhere between pathos and melancholy in stone. All of them are dwarfed by the mighty Hallgrímskirkja which was only completed in 1986 after having been under construction for almost half a century.

Modernism was first imported – Finnish star architect Alvar Aalto designed the Nordic House in Sämundargata in 1968 – then assimilated. The city's gigantic water tanks on Öskjuhlið Hill – nothing spectacular in their own right –were eclipsed by an imposing glass dome, its exterior catching the light of the chilly north, sparkling like a giant drop of water in the mornings and glowing fiery orange as the sun sets. Inside, visitors abound, flocking to the dome restaurant to be rotated 360° in the space of one hour. The views are so enticing that most don't wait a second turn but hurry off to explore, spurred on perhaps by the imitation geyser within the dome. This is, of course, merely a technical gimmick and nowhere near as impressive as the original Great Geyser to the northeast in Haukadalur. Somewhat like the genie in Aladdin's lamp, it grows to an incredible size once released from its earthly confines. The spectacle is worth the wait. When it feels like it, or when smeared with soap (literally!), the much-frequented attraction shoots 60 metres (197 feet) up into the sky before becoming a humble pool once again. Once the show's over it's not far to its chief rival, Gullfoss Waterfall, one of the most beautiful of Iceland's many cascades. A golden rainbow is summer, in winter the falls are transformed into an icy palace any snow queen would feel at home in.

It's just 40 kilometres (25 miles) from Reykjavík to the place called Þingvellir, where over 1,000 years ago the Vikings held their first Alþing. There are no historic buildings here – Iceland's oldest stone house on the island of Víðey is a relatively recent dwelling from 1755 – yet visitors are rewarded with a breathtaking volcanic landscape and geological phenomenon of the most unusual kind. The Allmannagjá

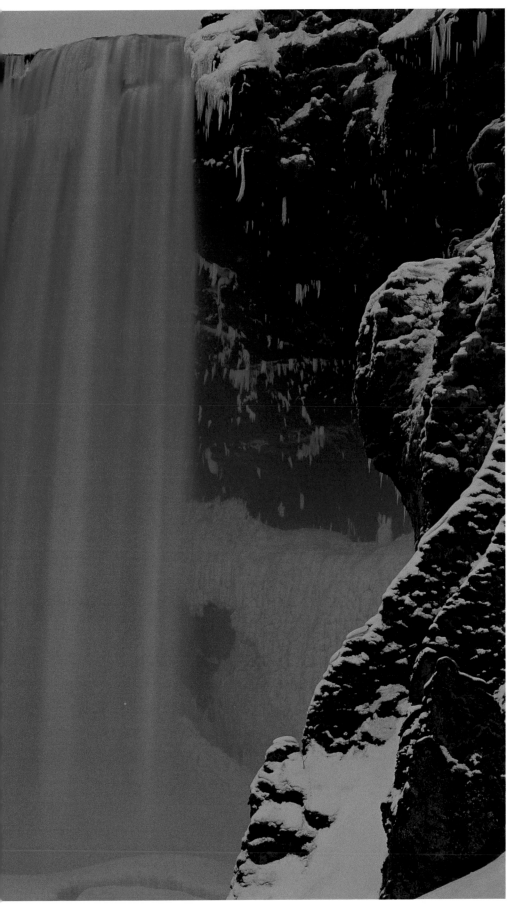

Gorge, where the tribal leaders once met, belongs to the Central Iceland Rift and is thus part of the Mid-Atlantic Ridge where the Eurasian and North American plates shift between two to seven centimetres (ca. one to three inches) each year.

GLACIERS, CRATERS AND GHOSTS

The Ring Road, Iceland's national route 1, is almost 1,500 kilometres (940 miles) long. It runs right round the island, linking the towns and cities along the coast (inland Iceland is very sparsely populated). Not so long ago travellers to Iceland frequently had an (unlikely) tale or two to tell about the conditions of the country's roads. Nowadays tarmac surfaces are no longer a luxury but the norm – at least on all main roads – and the infamous unmade tracks something of a rarity. Problems with road construction in Iceland are not, however, just attributed to the many challenges presented by the country's topography; trolls, fairies, elves and other ghostly characters also have a hand in the matter. A little while ago an engineer appeared on TV, claiming that a road he was working on which ran through terrain belonging to »the others« kept subsiding and only became fit for use when the danger area was given a very wide berth. The famous Goðafoss (Waterfall of the Gods) in northern Iceland also allegedly owes its name at least to immortal beings, to the heathen idols and carvings which were thrown into it in early Christian times. These seem to now be long gone, however, having sought out new, secret places to hide.

In contrast to this invisible world the southern half of the island is an absolute feast for the eyes. The glacial scenery of Mýrdalsjökull and Vatnajökull with the Skaftafell National Park is just one example. The ice glitters a mysterious blue against the green, yellow and red liparite rock around Landmannalaugar, framed by solidified streams of lava as black as the night.

Speaking of lava, over 200 years ago the molten rock north of Mýrdalsjökull erupted from more than 100 craters, blazing a solid trail 25 kilometres (15 miles) long. Since then 500 square kilometres (ca. 195 square miles) of land have been covered in a dark crust. Skaftáreldahraun, the area around the Laki Craters, is the largest lava field in the country to have evolved in historical times and can only be reached in off-road vehicles.

Another bevy of superlatives can be found at Eldgjá (Fire Gorge), serviced by a bus which traverses the highlands during the summer

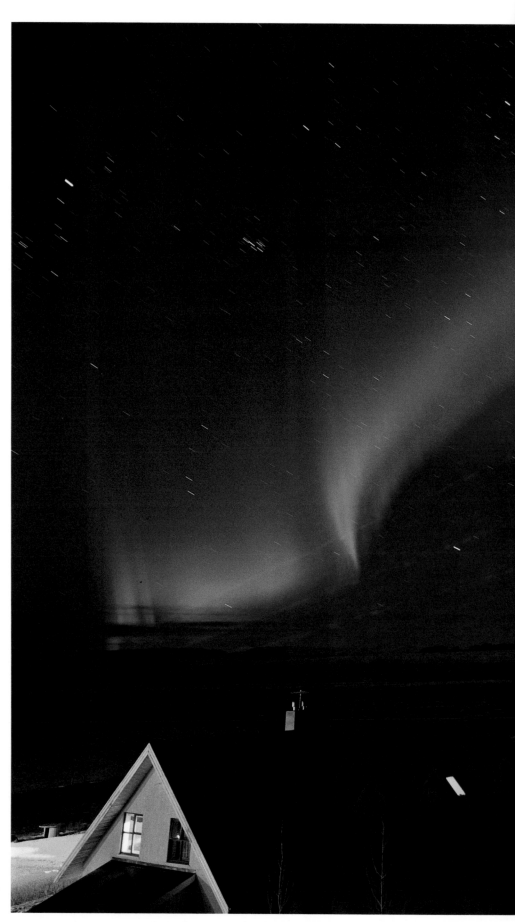

months. Those setting foot in the gorge, 30 kilometres (18 miles) long and over 1/2 kilometre (1/3 mile) wide, can claim to have stood in the largest volcanic rift in the world.

SPLENDID ISOLATION – THE FJORDS

Visitors travelling by ferry dock at Seyðisfjörður and usually hurry onwards without stopping. Those in the know don't. Here in the east there are just as many treasures awaiting discovery as elsewhere on the island and these have one major advantage; they don't have to be shared with countless others. Many of the indigenous population found the fjords too isolated, however, and abandoned their villages for more hospitable climes. The ca. 300 kilometres (ca. 190 miles) south from Seyðisfjörður illustrate just how solitary this area can be. In Höfn, the final stop on this particular leg of the journey, all those who met up before the long haul from Esbjerg in Denmark to Iceland (via the Faroe Islands and Bergen in Norway) reconvene as they make their anticlockwise circuit of the island along the infamous Ring Road. The little town is the starting point for glacial excursions out onto the icy wastes of the gigantic Vatnajökull and its associates. Long, swollen fingers of ice claw their way down to the sea. Elongated sandur deposited by meltwater at the tips of the terminal moraines forge between them, their quartz surface glistening in the sun.

Possibly one of Iceland's loneliest places – in the middle of breathtaking scenery – is Mjóifjörður (Narrow Fjord) with the practically deserted village of Brekka. The main access is from Egilsstaðir 40 kilometres (25 miles) away. The pass road zigzagging down to the sea is definitely not for the fainthearted – nor for those in a hurry. There are, however, fantastic panoramic views of the mountains and giddy glimpses down into deep chasms, where furious waters crash against the precipitous rock face. When you finally reach the ocean and stand alone on its windswept shores time becomes Icelandic – slower yet more intense. If you're treated to the sight of whales playing in the waves, then maybe one of them is the magician sent off to discover Iceland by the Danish king Harald Gormssohn. His report on the east of the country reads: »There was nothing but sand

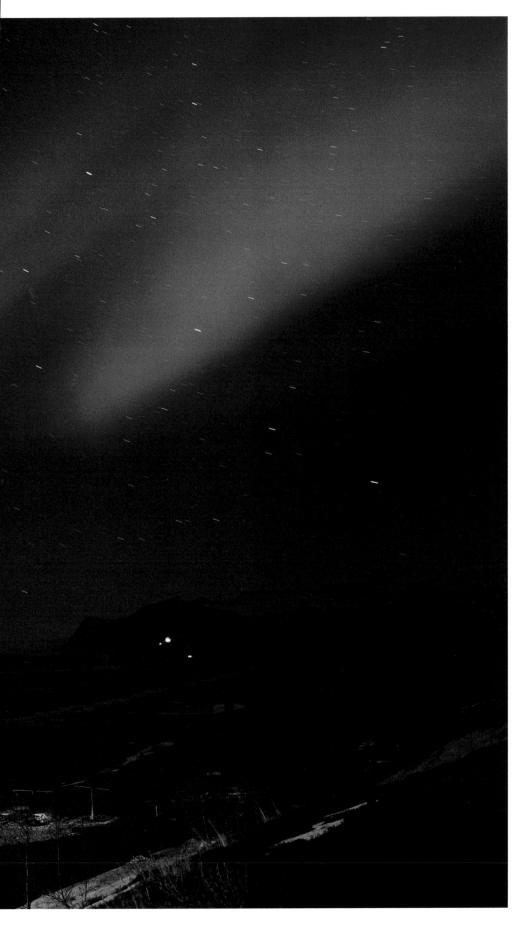

and wasteland and beyond them great waves with the sea so rough that ships may not sail here«.

COLONIES OF BIRDS AT MÝVATN AND ELSEWHERE

Mývatn or Midge Lake is a name all visitors to Iceland are familiar with. This and the surrounding countryside to the north of the country are a must on any holiday itinerary. Here you have everything which embodies the charm of Iceland in one spot: wild, mountainous terrain, with the earth bubbling just below its thin rocky surface (a series of eruptions between 1724 and 1729 covered the area in lava and ash), a magnificent lake and an ornithological paradise.

Iceland's bird world is unique and Mývatn is not the only place to enjoy it. On the island of Grímsey you can spot the extremely rare little auk; Breiðamerkurjökull, near the glacial lagoon of Jökulsárlón with its fluorescent miniature icebergs, is the largest breeding ground for the great skua in the northern hemisphere. Here, the Arctic skua zealously defends its territory against intruders – man included. Life is more peaceful on the cliffs of Heimaey, one of the Westman Islands, where millions of puffins nest in rocky caves.

TO THE CENTRE OF THE EARTH

Hamburg, 22 May 1864. The clock of the nearby Michaeliskirche strikes one thirty. It's Sunday. Axel, Professor Lidenbrock's nephew, cracks the key to a secret code in the »Heimskringla« (Orb of the World), the work of Icelandic chronicler Snorri Sturluson. The text reads: »Climb down into the crater of Yocul of Sneffels which the shade of the Scartaris caresses before the first of July, intrepid wanderer, and you shall reach the centre of the earth. I have done so. Arne Sacknussemm.«

This is also the opening of one of the most exciting adventures penned by Jules Verne, the »Journey to the Centre of the Earth«. The great Frenchman gives such an accurate description of the volcanic glacier Snæfellsjökull, dormant for over 2,000 years, that it's hard to believe he never went there himself. The most breathtaking views of the distinctive twin peaks are from the sea. Even the most well-travelled among us don't hesitate to count the mountain which towers up above the westernmost point of the Snæfellsnes Peninsular as one of best in the world – only if it does stand a mere 1,400 metres (4,590 feet) above sea level.

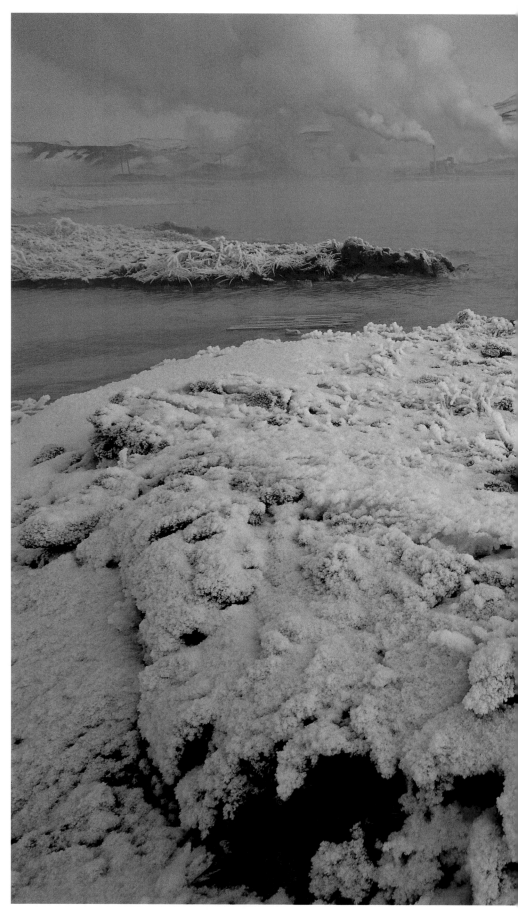

Here in the west of Iceland Sturluson and the people and places of the ancient sagas seem particularly omnipresent. Sturluson himself lived in Reykholt. From here it's not far to the coast and Borgarnes. The old Borg á Mýrum farm in the tiny town with just 1,800 inhabitants also has a Sturluson connection. And in Arnarstapi you can even meet one of the heroes of the sagas, Bárður Snæfellsnes, in person – albeit in stone.

JEEP VERSUS
ICELAND PONY

Once upon a time the deserted scree wilderness of the central highlands was a refuge for social outcasts; now it's simply buzzing with tourists from all four corners of the globe. Whereas a few still hike off into the solitary sunset, bowed under the weight of heavy backpacks, more and more rely on the four-wheel drive to whisk them off to isolated locations. The thin topsoil, which holds no water but which maybe one day could provide enough nutrition for more demanding plants than the few tough customers who manage to survive at present, is pounded to dust under the wheels of an army of off-road vehicles. Most of the locals agree it's a blessing that the pistes are only open for two to three months a year.

Before the Jeeps and Landrovers it was the astronauts. Prior to setting foot on the moon, the Americans practised in the Icelandic highlands – in Askja, to be precise, an enormous caldera which remained after the earth had spewed boiling magma into the atmosphere. The Americans may have felt they were on the moon; others are reminded of an inferno. Here the devilish smell of sulphur oozes from all pores of the ground. Just to drive the point home, the Víti Crater, steaming with warm water, is otherwise known as the Kingdom of the Devil or Hell. The icy blue waters of the nearby Öskjuvatn lake are almost a welcome relief.

Travel guides claim that the Blue Lagoon in the lava fields of Grindavík is »the best place to bathe between Europe and America«. The warm

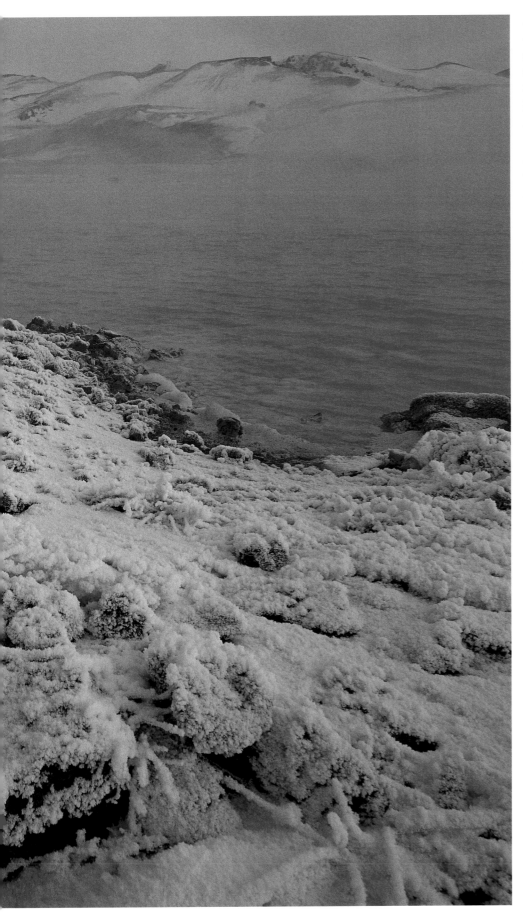

water piped up from 1,000 metres (3,280 feet) under the surface by a neighbouring power plant and converted into thermal energy has created an artificial lake. Visitors can swim here all year round, with the minerals contained in the water not only responsible for the fantastic blue sheen but also for the bather's general sense of well-being and even the cure of diverse ailments.

If you're the kind of person who likes extremes, then you should travel to Kverkfjöll in the highlands in the winter. Taking a dip in the glacial river here, fed by hot springs deep down under the ice, is a unique, almost spiritual experience. This is where the sheep – the true fans and connoisseurs of Iceland – are separated from the goats, whose spirit of adventure is largely proportional to the speed and power of their four-wheel drive. This proves totally useless in winter. The best form of transport is either your own two feet or travel on the back of an Iceland pony.

The history of this unusual breed of horse is at least as old as the first settlers. This tough, docile and undemanding creature was a loyal companion and workhorse in all walks of life for centuries. The island's isolated position and the islander's fear of imported diseases – even today no other breeds of horse are allowed into the country and exported Iceland ponies not readmitted – ensured that the thousand-year-old race has survived. It is as enduring as it is unusual. Iceland ponies can walk, trot and gallop like any other horse but they can also go into fourth or even fifth gear; when they pace they hop from two legs on one side to the two on the other. The most comfortable gait for the rider is, however, the tolt. The horses' legs move as they would when walking but much quicker, enabling even the most inexperienced of riders to stay in the saddle. Odin, the father of the gods, must have felt extremely relaxed astride his loyal steed Sleipnir, who is said to have had eight legs ...

Page 22/23:
In 865 Flóki Vilgerðarson from Norway landed here in Vatnsfjörður but left after enduring just two of the country's bitter winters. His battle with the cold prompted him to christen his inhospitable abode Iceland.

Page 24/25:
Jökulsárlón in the east of the island is a deep glacial lake where the Breiðamerkurjökull calves. You can drive across the icy waters in an amphibious vehicle and get right up close to the shimmering icebergs.

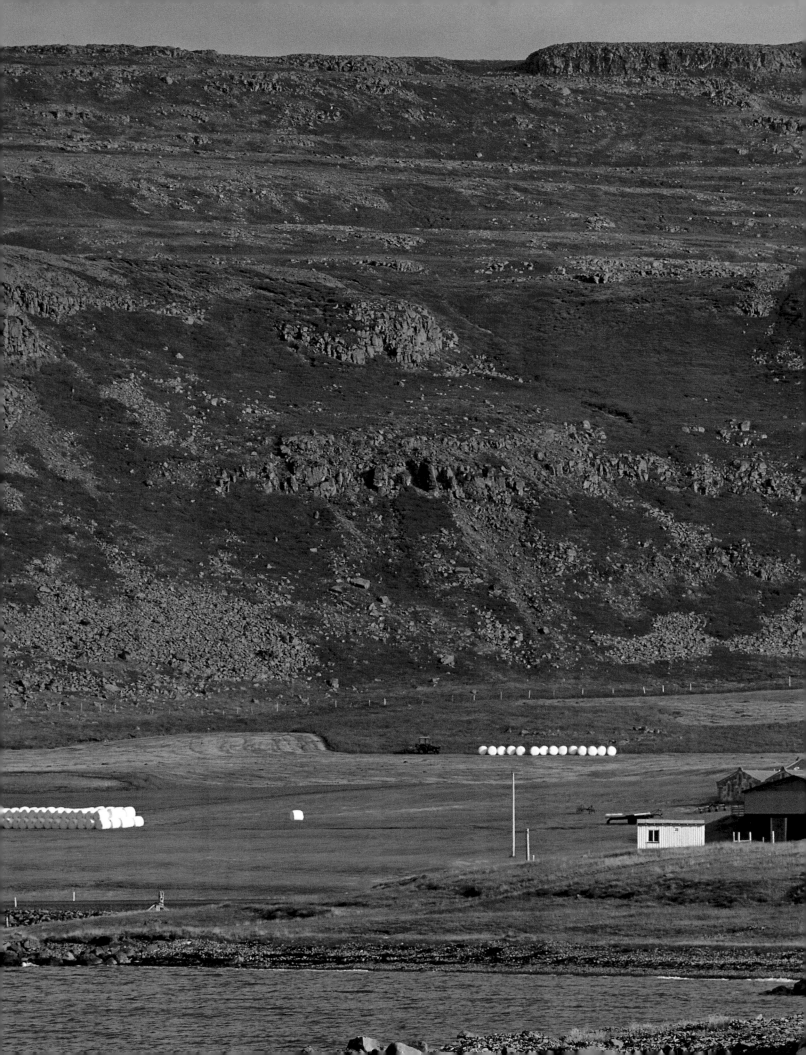

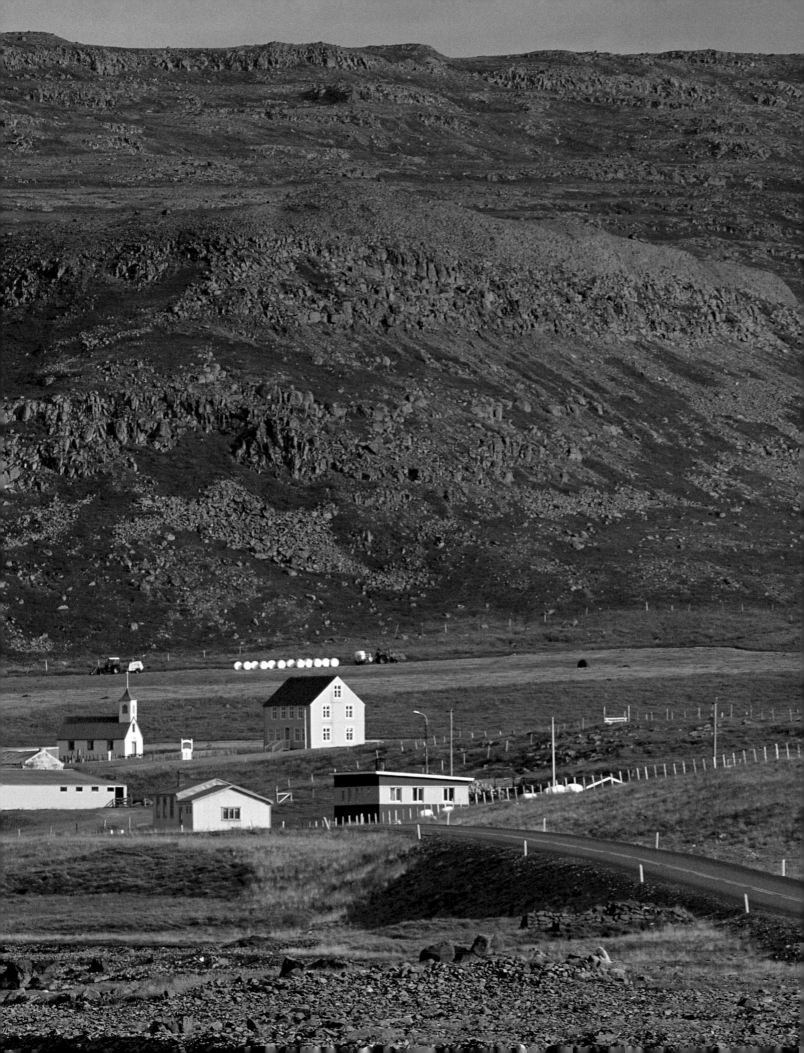

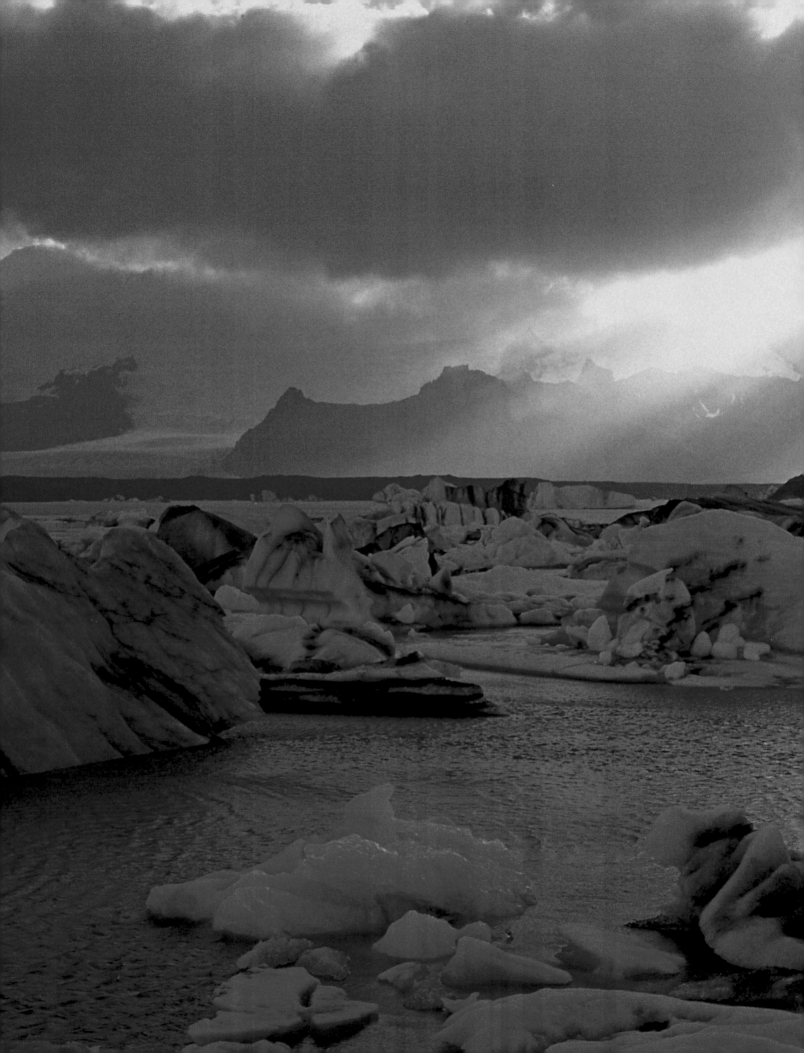

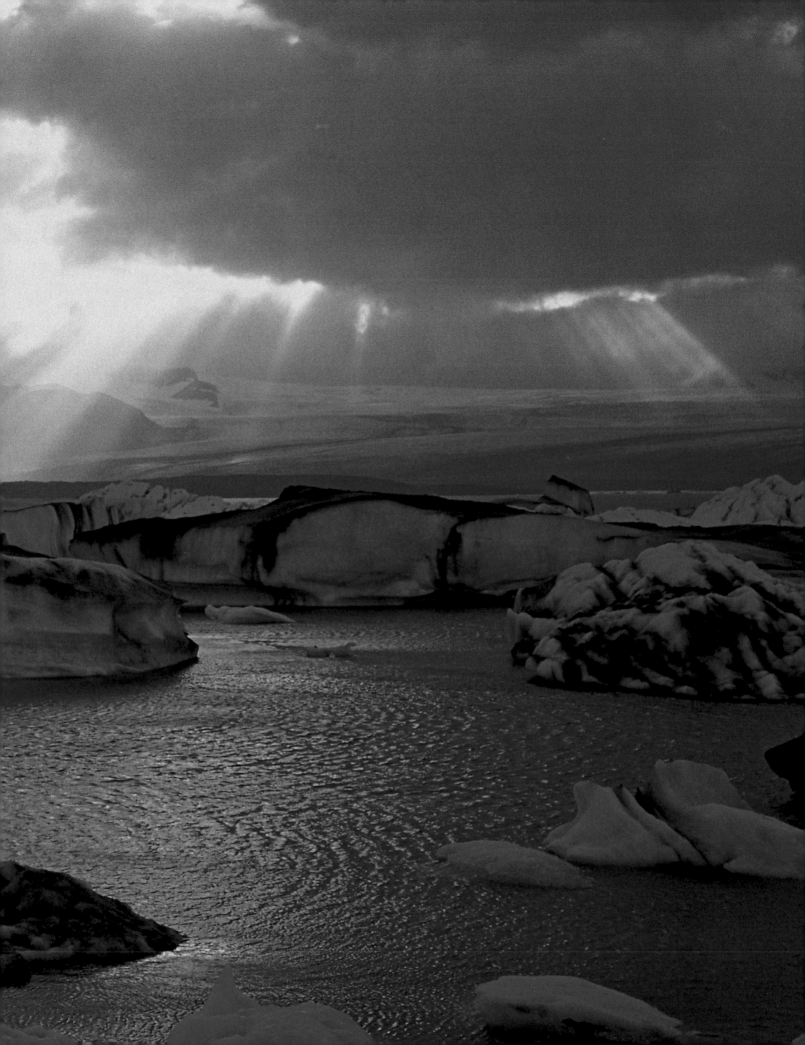

THE PULL OF THE CAPITAL

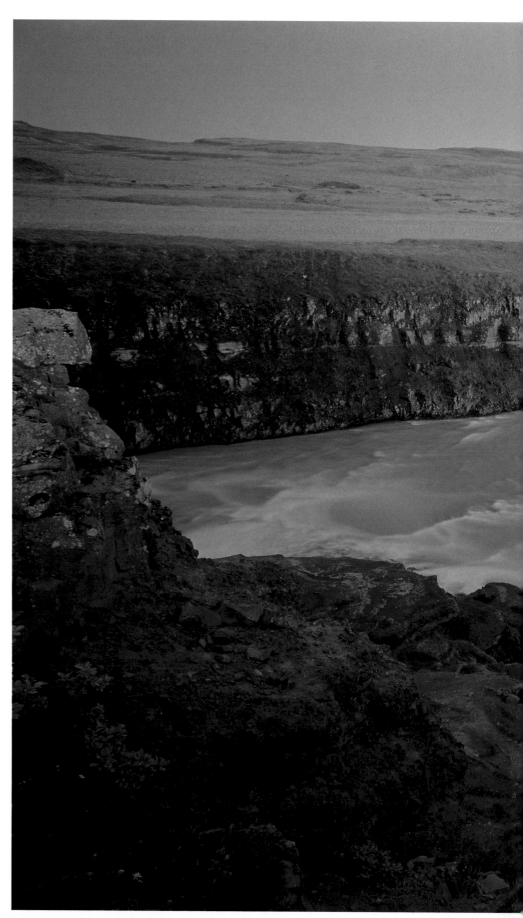

Page 28/29:

From the top of the steeple of the Hallgrímskirkja in Reykjavík there are magnificent views out across the city and surrounding countryside. The church, named after a famous 17th-century religious poet, was begun in 1945 and only completed four decades later.

Right:

Gullfoss, the »Golden Waterfall«, hurtles down into the depths from two precipitous rocky ledges. The falls are fed by the glacial Hvítá River which over the course of a good 10,000 years has carved a deep gorge into the highland plateau. The water glistens gold (hence the name) in the evening light.

Despite being the most northerly metropolis in the world, Reykjavík has no trouble keeping warm. The many hot springs provide ample energy to heat not just the buildings but also the outdoor swimming pools and even the pavements in winter. Here it's not the chimneys that smoke but the ground. Legend has it that it was Odin's personal request that the first settlers make a home for themselves here in the geologically turbulent west rather than in more fertile pastures. The pull of the capital is still strong. Many from the 'provinces' continue to come here in the hope of finding a better job and enjoying a higher standard of living.

Outside Reykjavík there isn't a second harbour providing work for another 400 kilometres (250 miles); that's the entire length of the south coast. Instead there are fire and ice, glaciers and volcanoes which threaten and destroy the environment – and also form it. The southernmost tip of Iceland, Cape Dyrhólaey, which drops 120 metres (394 feet) down to the sea, is one such example. Once an island, like many others it has now been welded to the mainland by volcanic and glacial activity. In fine weather you can see the Vestmannaeyjar from here.

North of the capital is the Snæfellsnes Peninsular which the locals claim has something of everything with respect to Iceland's diverse scenery. Snæfellsnes dips a solitary, cautious finger into the ocean, while above it the Westfjords (Vestfirðir) claw their way hungrily into the churning waters of the Atlantic. This natural beauty spot at the end of the (Icelandic) world seems to attract only tourists, however, and not many wander up this far. In summer, though, they still manage to outnumber the few remaining inhabitants of the northwest.

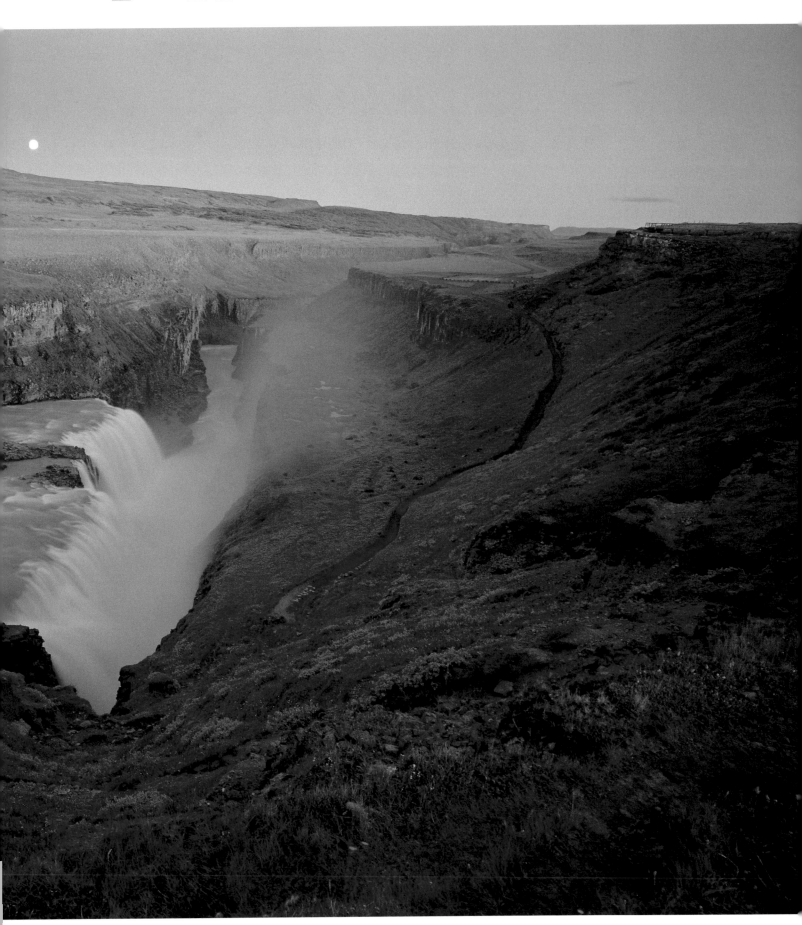

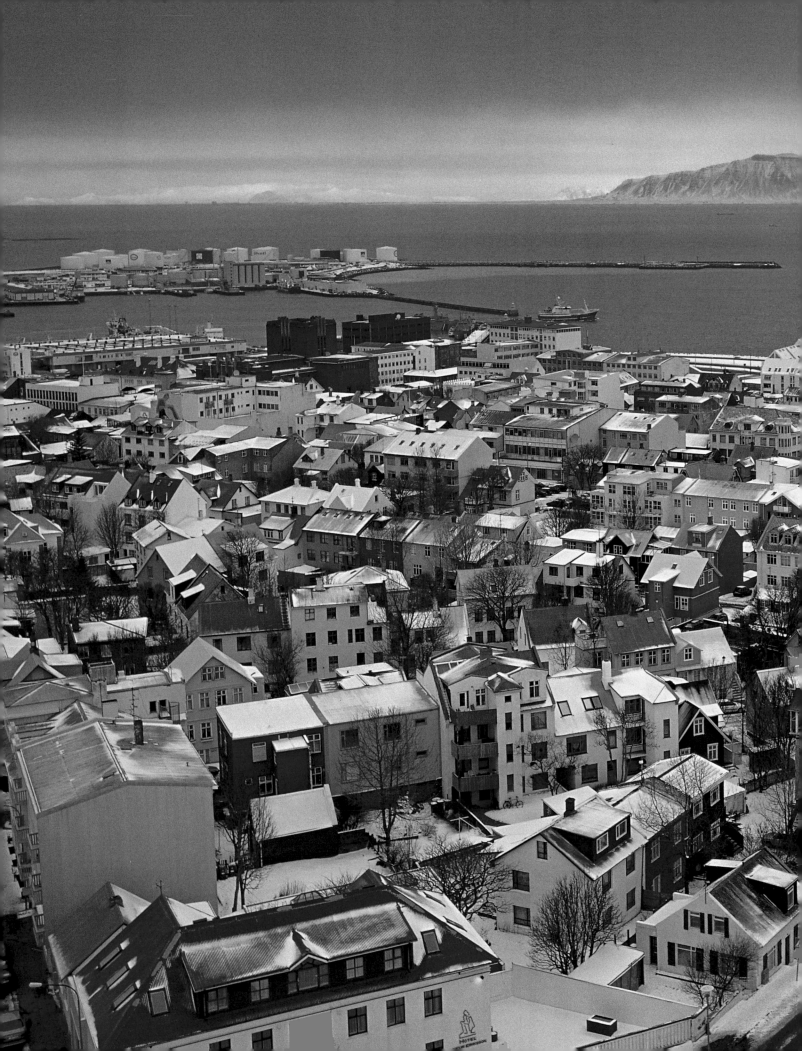

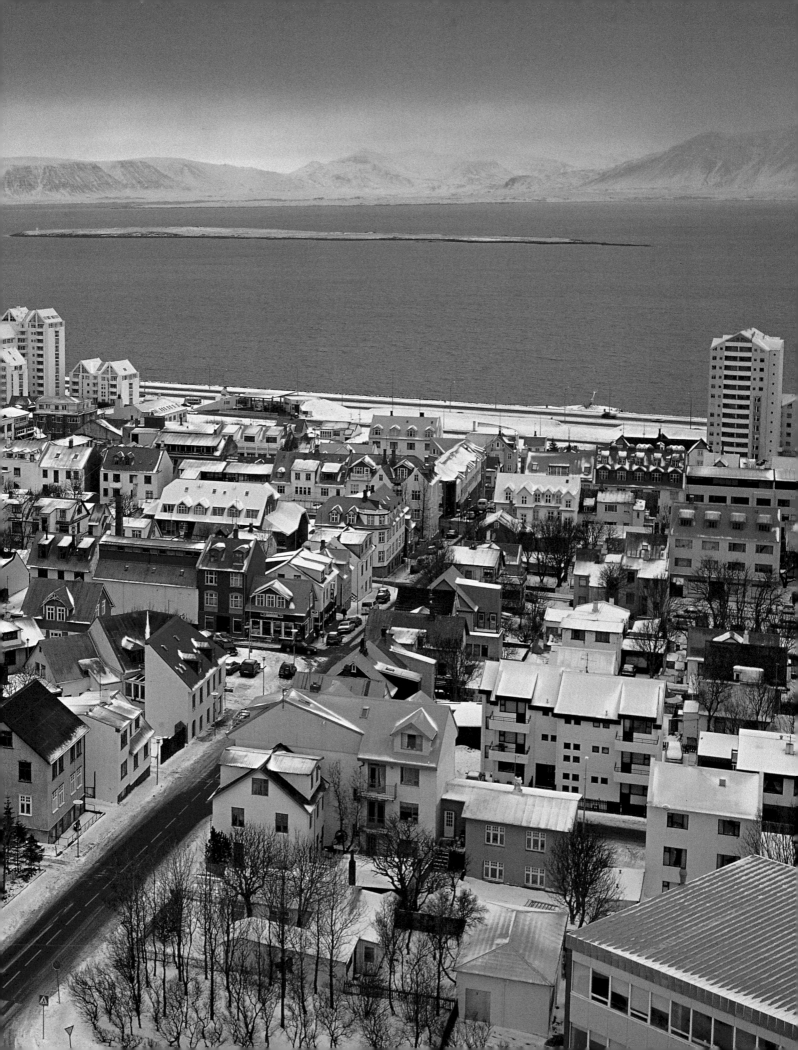

It's very easy to make friends with the locals. Visitors are addressed as the Icelanders address each other; either in the informal or by their first names, if known.

A coffee house in Reykjavík. The people of Iceland are a nation of coffee-drinkers. Their enthusiasm for the bean is so great that it's not un-usual to find pots of coffee set out in supermarkets or public buildings for visi-tors to help themselves to.

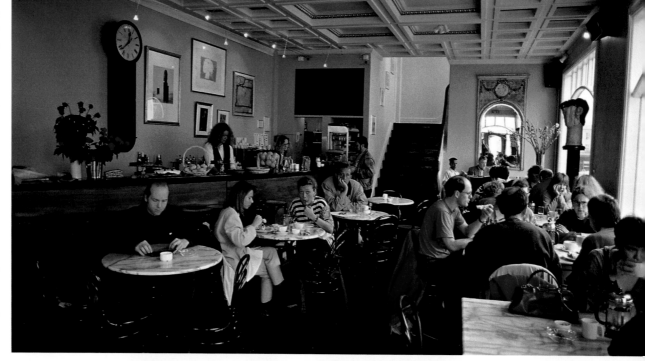

Right page:
After computers and mobile phones cars are the Icelander's favourite toys. Every second person has a car – which in the extreme climate admittedly doesn't last that long.

Reykjavík, together with four other towns, was given its town charter by the Danes in 1786. At that time the capital had just 170 inhabitants. Today Greater Reykjavík is home to ca. 165,000, many of whom live in concrete houses which can with-stand Iceland's earth-quakes better than the city's more picturesque wooden dwellings.

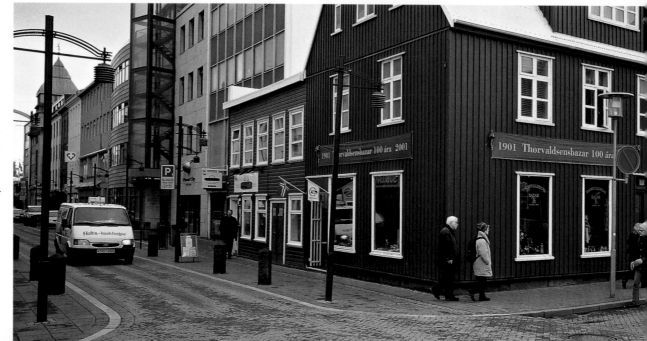

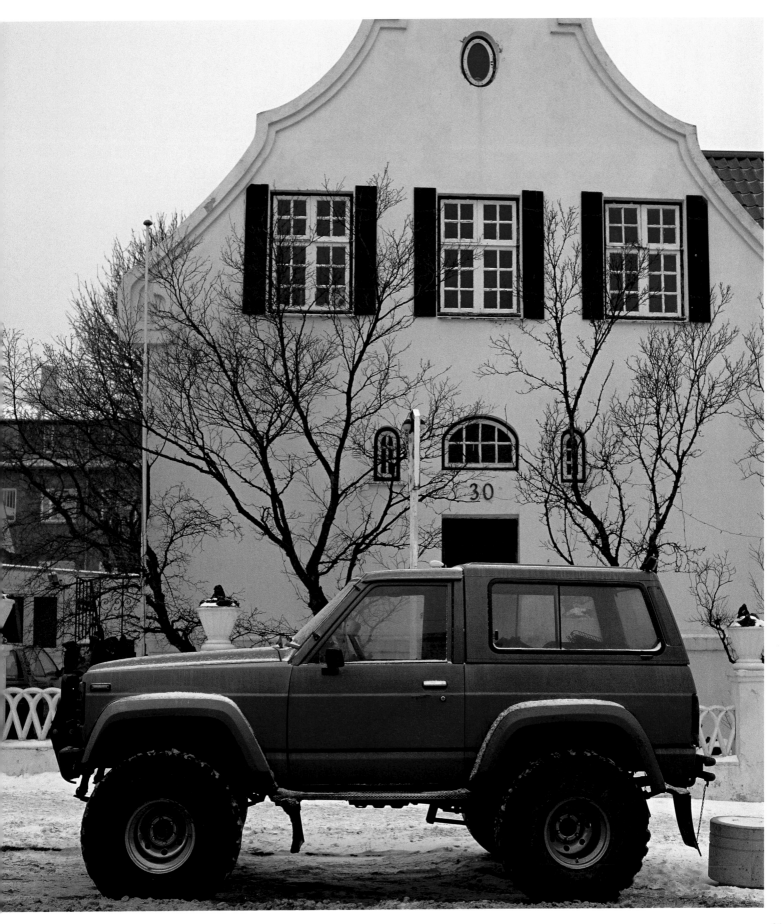

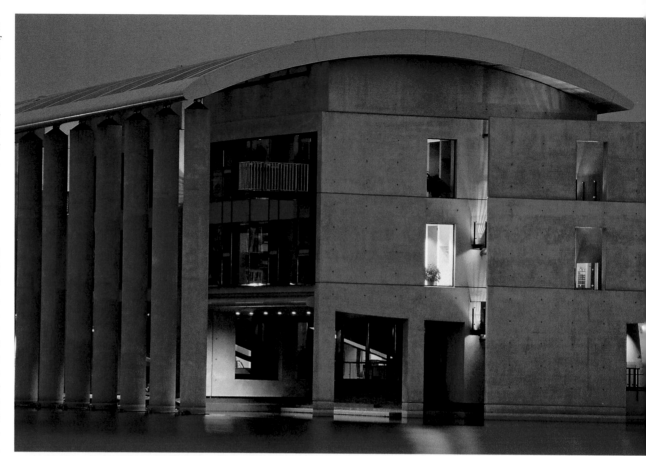

Right:
In the historic centre of Reykjavík, on the northern shores of Lake Tjörnin, stands the new town hall. The modernist building, erected in 1992 amongst the old villas of the city on a man-made mound, is not to everyone's taste.

Below:
For three hundred years Scandinavian Vikings sailed the seas as pirates, conquerors and explorers. Their excellent navigational skills and modern ships, which could carry livestock plus a twenty-strong crew, brought them to Iceland. This monument in Reykjavík commemorates the settlement of the island.

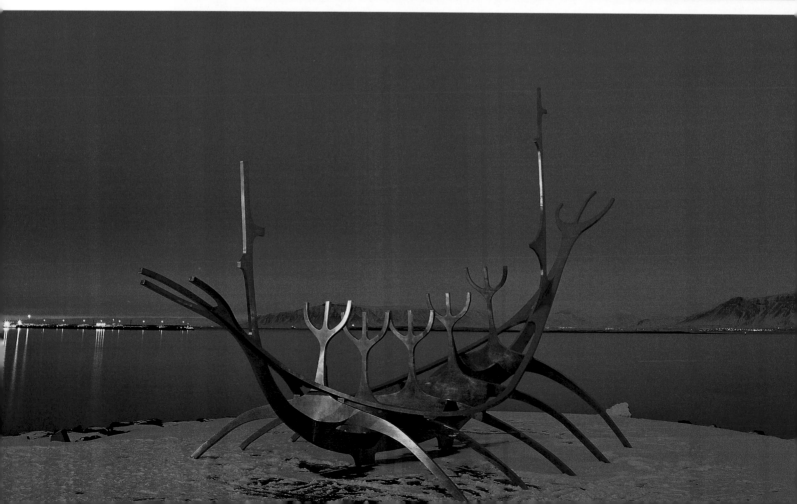

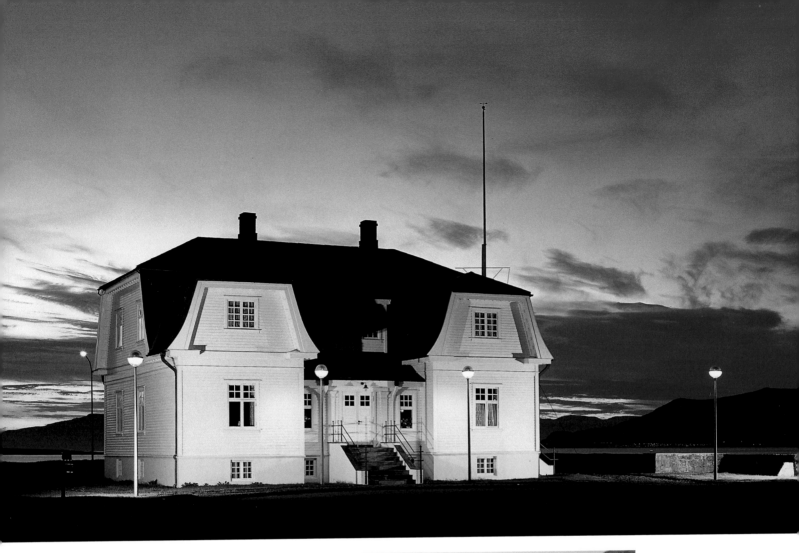

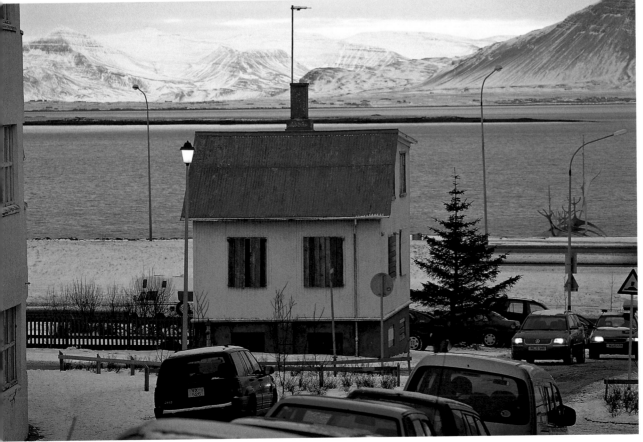

Above:
Höfði House is the official venue for city functions in Reykjavík. Roughly halfway between Moscow and Washington, this 100-year-old building is where Mikhail Gorbachov met Ronald Reagan in 1986 to discuss a mellowing of political relations and disarmament.

Left:
In the heart of Reykjavík, here near the Sæbraut promenade with its Viking ship sculpture, parking is something of a problem.

33

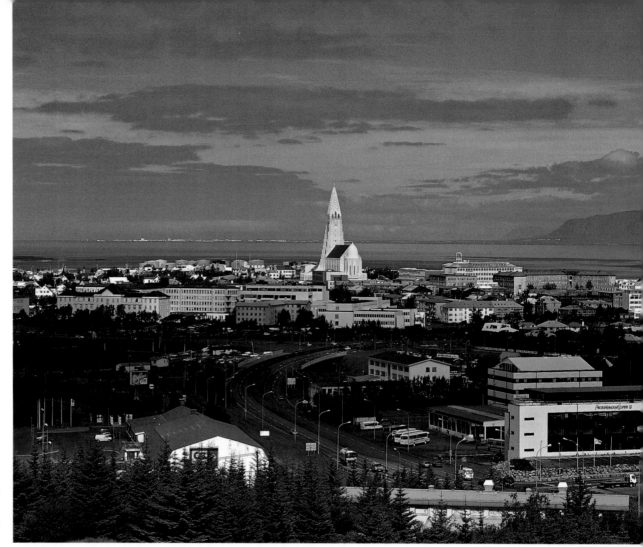

Top and bottom right:
Öskjuhlíð Hill is crowned by enormous reservoir tanks which hold 24 million litres (5 million gallons) of hot water. The futuristic receptacles also house a restaurant, palm garden and exhibition hall. The revolving Perlan dome, which turns a full circle in one hour, has magnificent views of Reykjavík.

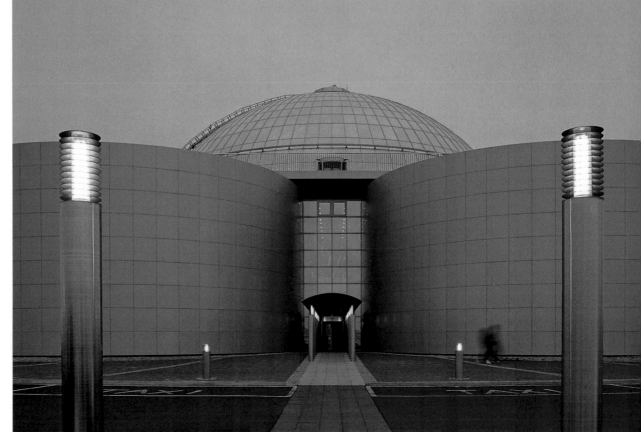

Right page:
View from the foyer of the hot water tanks up into the pearly Perlan dome with its café, gourmet restaurant and viewing gallery. On a clear day you can see for miles, out across Reykjavík to the glittering sea and majestic hills beyond.

THE FIRST PARLIAMENT IN THE WORLD

The setting couldn't be more spectacular; two deep gorges cut through a fantastic lava landscape, decorated with moss and lichen, wild flowers and tangled shrubs, reflected in the sparkling waters of an enormous lake. This idyllic spot is a mere hour's drive northeast of Reykjavík and is where in the summer of 930 the first Alþing, Iceland's national assembly, was held and the free state of Iceland proclaimed. Þingvellir, the »holy place of all Icelanders«, covers ca. 50 square kilometres (19 square miles) and was made a national park in 1930. It was also here that

on 17 June 1944, 1,000 years after the birth of the free state, the Republic of Iceland was called into being.

The Alþing marked the end of the acquisition of Iceland (which begun in 874) and the beginning of a new dawn in Icelandic society. The godords established at the Settlement, communities of temple-goers which later became centres of worldly power, were based on Norwegian models which were no longer suitable under the new system of administration. Wise scholar Úlfljótur thus spent three years studying the laws of his motherland and adapting them to suit the circum-

HUGVEKJA TIL ÍSLENDÍNGA.

Dagur er upp kominn,
dynja hana fjaðrar,
mál er vílmögum
að vinna erfiði.

FRIÐREKUR konúngur hinn sjöundi hefir á fám stundum leyst þann knút, sem lengi hefir þótt býsna fast riðinn, og sumir hafa viljað telja trú um að væri gjörður handa eilífðinni, svo að hvorki konúngar né nokkur annar ætti með að leysa hann. Lærðir menn hafa látið sér um munn fara, að þó að Danakonúngar ætti vald á að fara með lög og rétt hvernig sem þeir

Top left:
Together with a group of students, in 1845 Jón Sigurðsson re-established the historic Alþingi in Reykjavík. His name has become synonymous with the new, independent Iceland.

Left:
Alþingishús in Reykjavík, Iceland's houses of parliament, dates back to 1881. The grey basalt building is the work of Danish architect Mehldal.

Above:
Hrafnseyri has a museum dedicated to national hero Jón Sigurðsson whose birthday (June 17) is a national holiday.

Top righ
This lithograph from 184 shows the Allmannag Gorge which runs alor the Þingvellir fault the west, where fro 930 to 1798 the Alþin convene

AND THE FREE STATE OF ICELAND

stances prevalent in his new homeland. On his return he presented his ideas to the assembly at Þingvellir. Announcing his visions to those present from atop a rocky spur (the Lögberg or Law Rock, now marked by a stone plaque and Icelandic flag), Úlfljótur and all those who succeeded him must have had both a sound voice and a phenomenal memory; until 1117, all laws were recorded solely in the minds of those who were required to recite them off by heart at the annual parliamentary sittings. Parliament was also responsible for any matters of jurisdiction. Sentences were carried out by the victors of the dispute. For a long time banishment was the worst form of punishment; wrongdoers were later hanged, drowned or strangled. Records of various places of execution at the Alþing have been handed down to us. »Witches« were burnt at the stake in the Brennugjá or burning gorge whereas the Drekkingarhylur or drowning place was reserved for women who had either had illegitimate children or had deceived or even done away with their husbands. The Almannagjá (Everyman's Gorge) is named after the members of the first parliament which is said to have met here.

FEASTING AND WRESTLING

The Alþing wasn't all law and order, however; there was also a lot of fun. People ate and drank, went to market, got married, sang songs and recited poetry, joined in games – and wrestled. The latter in its Icelandic version, »glíma« , is still extremely popular. The contestants wear a belt and a band around the thigh. The aim of the sport is to wrestle your opponent to

the floor using just seven permissible holds; the first person to touch the ground with any part of the body above the knees has lost.

Today Iceland is one of the most modern states in the world yet tradition still plays a major role. Until well into the 18th century there were no villages here, just single farmsteads as in the time of the sagas. One such turf holding in the Þórsá Valley, buried under Hekla lava in 1104, was excavated and reconstructed in the last century. Other turf huts documenting what life was like in the days of yore can be visited at Reykjavík's Árbæjarsafn Open-Air Museum and at Glaumbær in the north of the country.

The latter is also linked to the life and times of a certain Þorfinnur Karlsefni, who in ca. 1000 accompanied intrepid Leifur Eiríksson on his journey to America. Unlike this early explorer, who returned home from his voyage of discovery, the almost 20,000 Icelanders who set off to start a new life in the USA between 1870 and 1914 did not. The interesting Museum of Emmigration in Hofsós on the Skagafjord is dedicated to them.

If you ask an Icelander which event in the recent history of his or her country holds the greatest significance, he or she might single out March 1 1989 – explaining with a smile that this was the day on which the long 80-year-ban on beer was finally lifted…

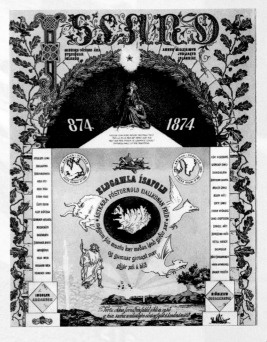

Far right: *This poster was printed in 1874 to commemorate 1,000 years of Iceland, one millennium after the first official settler*

Ingólfur Arnarson set foot on the island. The map in the centre is surrounded by Iceland's guardian spirits: the giant, dragon, bird and bull.

37

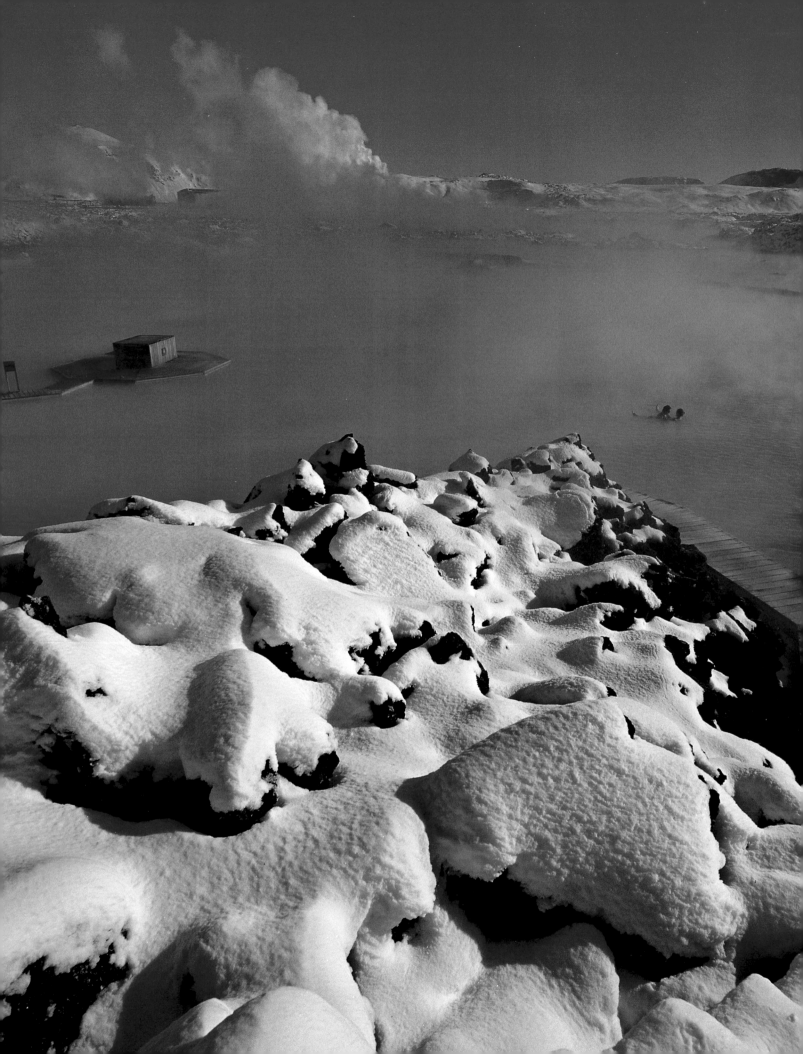

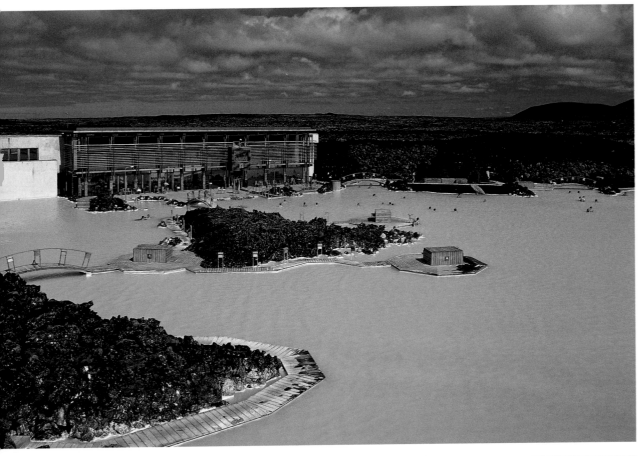

Left page:
Even in the winter the
temperature of the water
in the Blue Lagoon on the
Reykjanes Peninsular is
a steamy 38°C (100°F).
The giant heated pool,
the by-product of a neigh-
bouring geothermal
power plant, can be
enjoyed all year round.

Originally an old lava
crater right next to the
power plant, in 1999 the
lagoon was moved to a
less industrial-looking
site. Visitors can now
wallow to their heart's
content in a modern,
spacious bathing area
with all the mod cons.

What has remained is the
milky water, coloured
by algae and silicic acid,
which changes from
turquoise to deep marine
blue with the light. It's
also claimed to have
healing properties and
to cure skin complaints,
such as psoriasis.

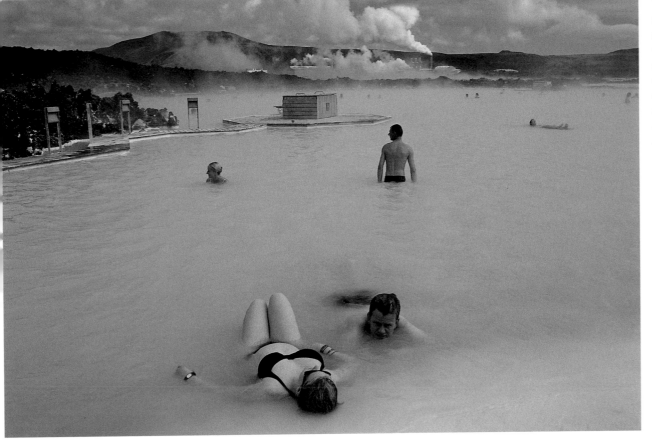

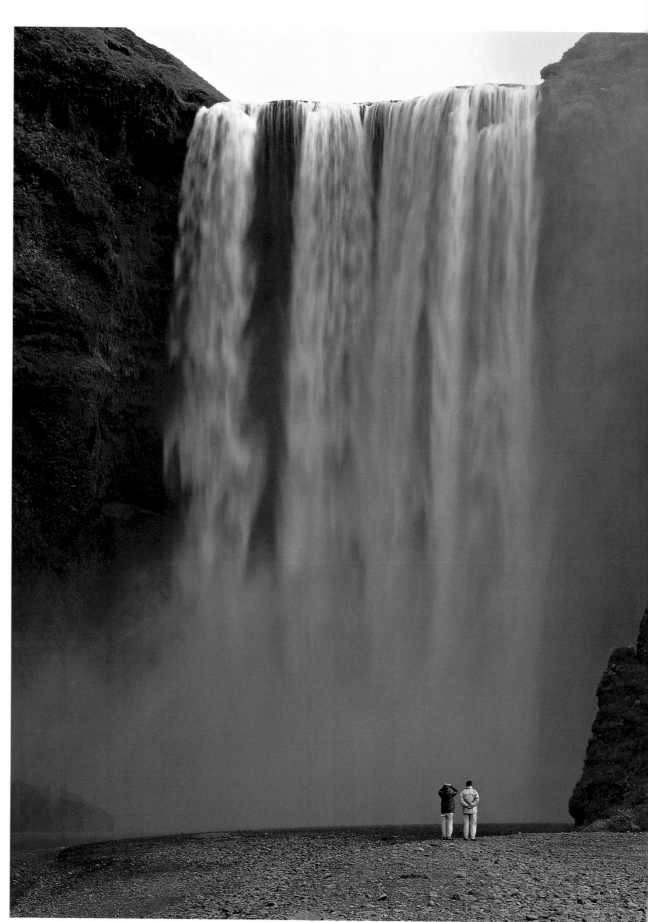

Right:
The Skógafoss is named after the river crashing down the cliffs which formed the coastline here before the sea level dropped. As »Skógar« is Icelandic for »wood«, it is assumed that early settlers once found trees here.

Right page:
In 1978 the Skógafoss was placed under a state preservation order. Hikers climbing the falls pass several smaller cascades along the way and in Ytri-Skógar discover an original museum run by an extremely original individual who is only too pleased to show off his unusual exhibits to interested passers-by.

40

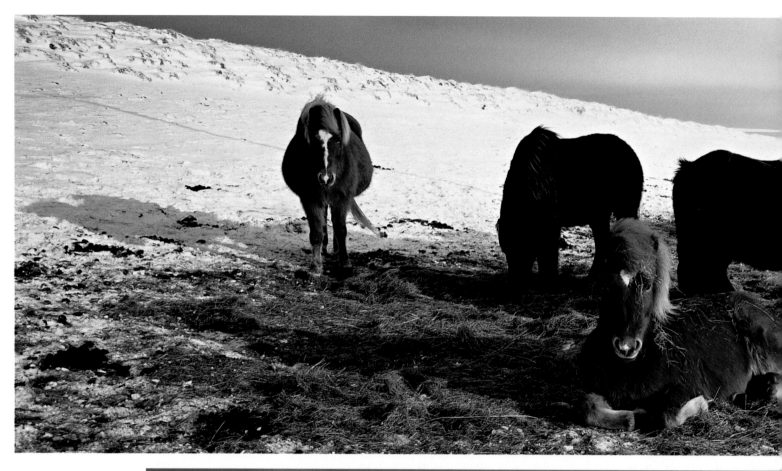

Above:
Iceland ponies can easily survive in the wild; only those animals used for riding are stabled over the winter months. Horses are broken in at the age of four or five in a process which is long and difficult. Patience reaps rewards, however; ponies aged 20–25 are as fighting fit as their younger relatives.

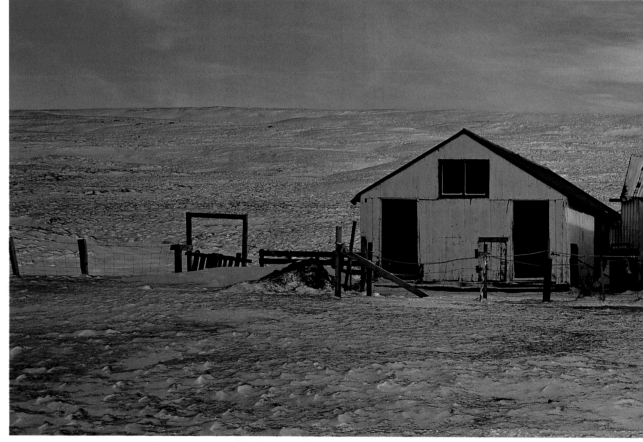

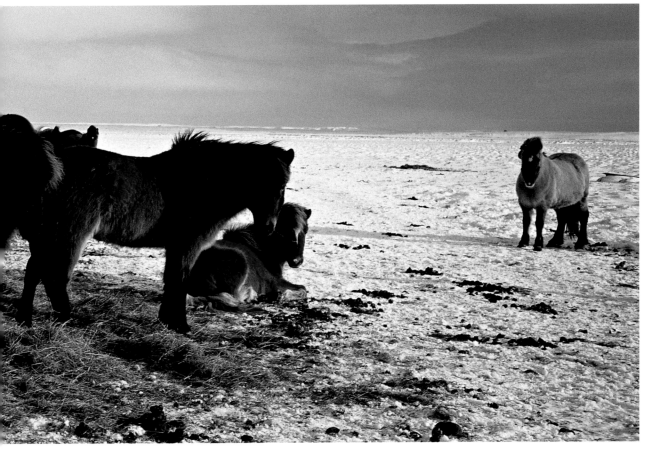

Below:
A farm near Reykjavík. Iceland's ca. 4,000 farmers provide enough meat and dairy products to feed the entire country. A good percentage of the approximately half a million sheep is exported, with the number of exported cattle also on the increase over the past few years.

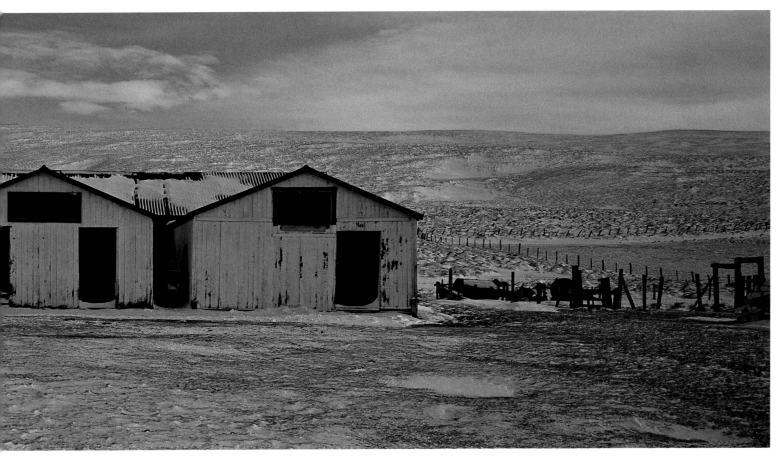

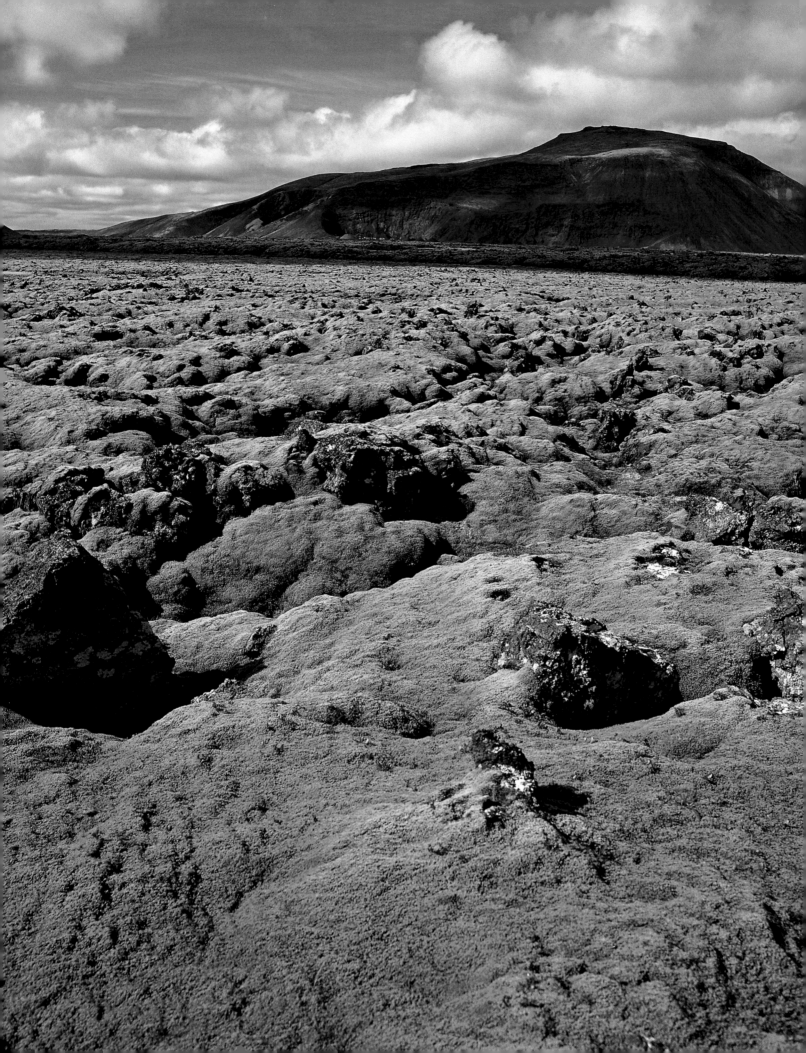

south of the central Hengill volcano, which last erupted ca. 2,000 years ago, is popular with hikers.

Below:
Mountain landscape near Borgarnes. The tiny town in the west of Iceland was the home of Egill, one of Iceland's legendary heroes.

Below:
From 1056 to 1785 the diocesan town of Skálholt was of great importance to the historical and cultural evolution of the country. The present church – the

town's twelfth – was conse-crated in 1963. Iceland's bishops are laid to rest in its crypt. The acoustics of the building are fantastic which is why in summer it's often used for concerts.

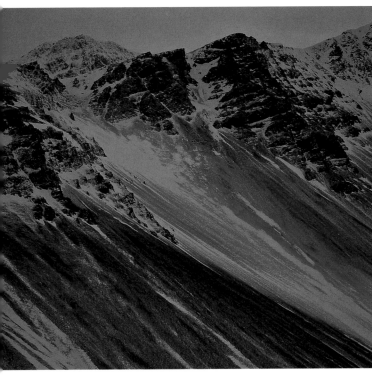

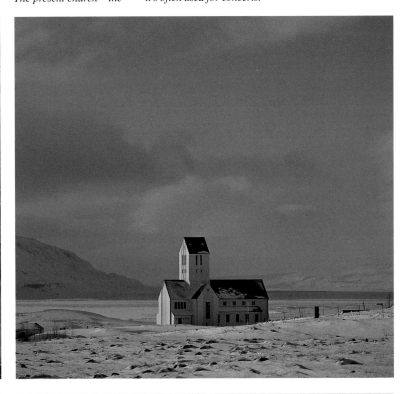

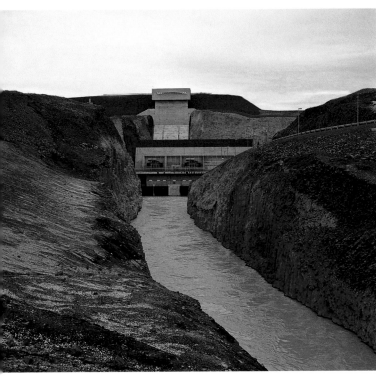

Straumsvík with electricity. It can produce 210 mega-watts – more than half of the country's other power

plants. The River Þjórsá provides the water which is fed into the plant through channels and tunnels.

Above:
Up in the highlands near Hrauneyjar. The (in)famous Sprengisandur Route pas-ses through this desert of

lava, passable by car only during the brief Icelandic summer from mid-July onwards. The lunar plains

were first tackled by vehicle in the 1930s.

45

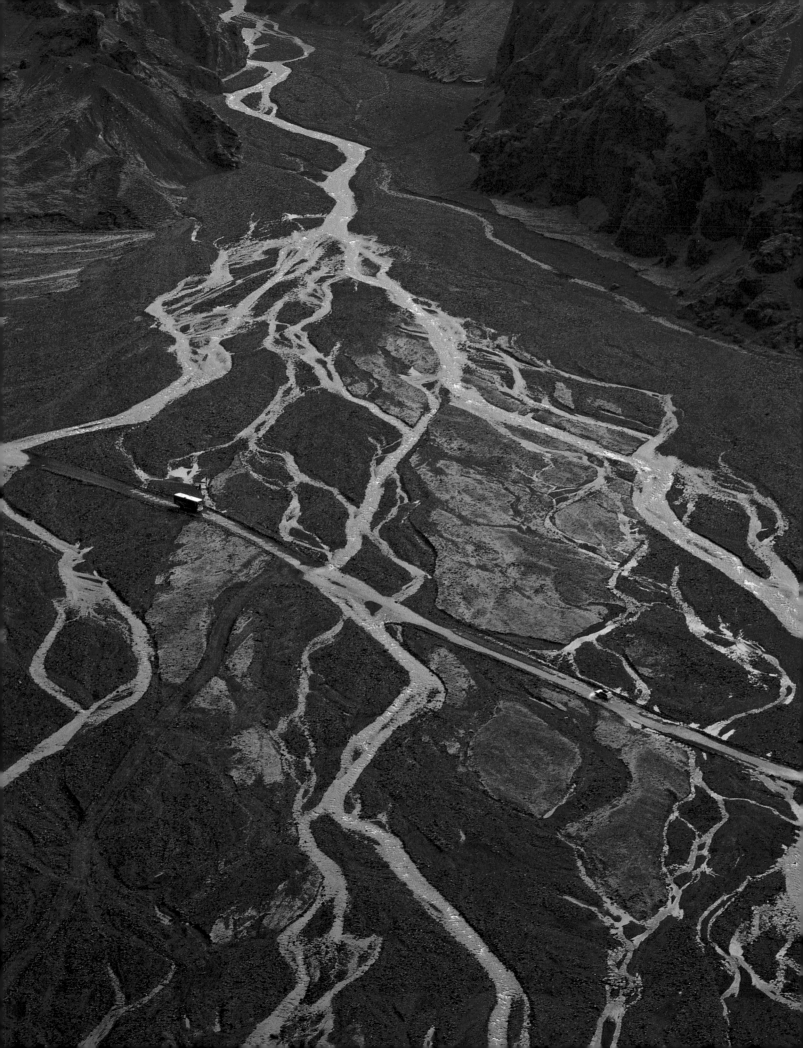

ft page:
Þórsmörk nature park.
rough the valley of Thor,
e god of thunder, the icy
gers of the Krossá River
w their way down to the

sea. Inexperienced motor-
ists are often stranded
here; accidents are also
not uncommon, sometimes
proving fatal.

Below:
The first people to settle
in Þórsmörk are named as
Ásbjörn and Steinfinnur
Reyrketilsson in the
historic »Landnámabók«.
Today the wild valley is
the domain of hikers and
trekkers.

Below:
On the Ring Road near
Vík í Mýrdal. The legend-
ary route round the island
is now almost completely
tarmacked (minus a few

tiny sections in the east).
One of the route's biggest
hazards are its sheep
which meander onto the
road regardless of the
traffic.

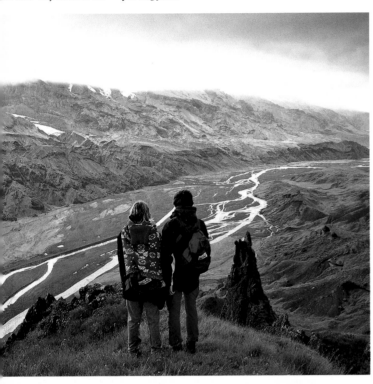

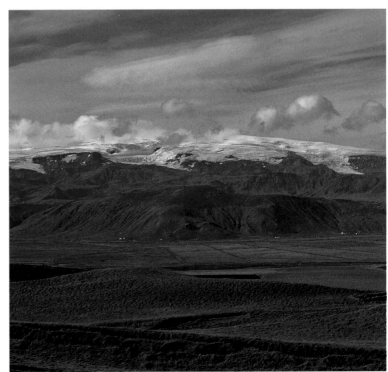

bove:
ertain parts of Þórsmörk,
ich as Húsadalur to the
rth, can be reached by
is.

Above:
View of the snowy peaks
of the Mýrdalsjökull from
Dýrholaey, a steep basalt

cliff dropping 100 metres
(300 feet) down to the sea.
Thousands of sea birds nest
in its crags and precipices.

47

TROLLS, FAIRIES AND ELVES –

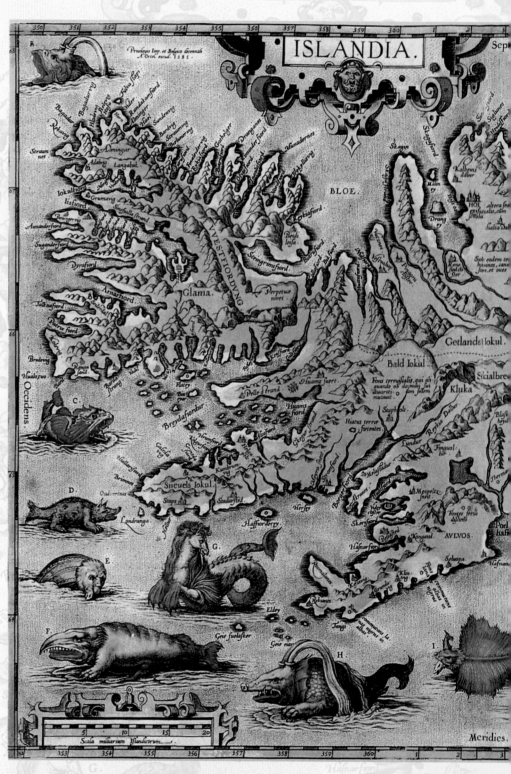

Norway's trolls, Ireland's leprechauns and Cornwall's pixies live on in national legends and fairytales – and on the shelves of tacky souvenir shops, where the little people in plastic, porcelain and plush fur fabric, usually invisible to mere mortals, obediently line up and wait to be sold.

Iceland is a different story altogether. Kobolds, goblins and gnomes are almost real and a part of day-to-day life. »Whether member of parliament or member of the highways department, all say that it's also not worth it financially to deny their existence«, claims historian Magnús H. Skarphedinsson, who for two decades has collected and recorded the tales and experiences of his fellow countrymen and women on the subject of Iceland's secret community. You can find out more at his Elf School in Reykjavík. You may not be able to suppress a smile or two at the opening lecture, but once you find yourself at the mystical places of Reykjavík on the follow-up walk, you may not be so sceptical after all. In the capital alone there are over a dozen alleged sites belonging to the »hidden people« which have even been protected by law. The best known of these is a rock on the edge of the city where the Ring Road forks north and south. The highway has been scheduled for expansion on more than one occasion and each time the infamous stone was in the way. Invisible powers did all they could to protect their abode; pneumatic drills shattered into pieces, JCBs refused to start and labourers fell mysteriously ill. Before the undertaking grew into a full-scale fairy war – the first in Icelandic history – a medium was able to make contact with the little people and reconcile them with their fellow (human) beings.

THE ELF CAPITAL

Despite these spectacular events not Reykjavík but Hafnarfjörður 10 kilometres (6 miles) away is the elf capital. The commune in the midst of a lava field today has just under 20,000 inhabitants – those visible and above ground – with many more thought to be hidden away out of sight under the earth's crust. The Dvergasteinn or Dwarf's Stone next to the church, the

Left:
One of the few Icelanders who claims to have come face to face with the elves is artist Erla Stefánsdóttir. Her fairy masks graphically depict the little people as she sees them.

Above:
On this old map from 1583 the coast of Iceland is inhabited by all kinds of terrible sea monsters. Inland the island is dominated by the dreadful fire breathing Hekla.

THE LITTLE PEOPLE

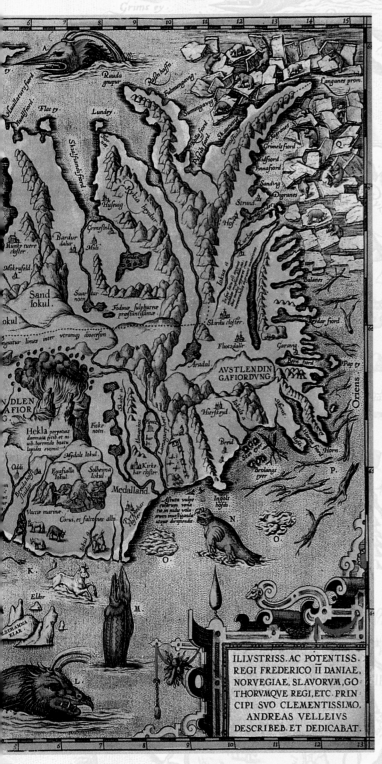

boulder which almost blocks off the Merkurgata and the Hamarinn lava cliffs in the heart of town, said to be where elves of royal lineage hold court, are claimed to be solid proof of their existence. Those wanting to get a little closer to the underground folk need to acquire a town plan to the Hidden World of Hafnarfjörður. It has been based on accounts given by the seer Erla Stefánsdóttir, who promises all interested parties that: »As soon as you become aware of the Hidden People living in every front garden the lava comes alive in its own special way.«

Even if you're not explicitly seeking a close encounter of the elfin kind you may not be able to avoid it; many of Iceland's place and street names at least refer to the »álf« or elf in passing. The most romantic fairy(tale) village on the island makes an exception. Borgarfjörður Eystri is elfin in all but name and lies mysteriously nestled between bizarre mountains and icy sea. Driving northeast from Egilsstaðir, the stone barrier rapidly approaching seems to mark the end of the world. Coming closer you can make out a faint line, a squiggle, which zigzags up the sheer rockface and disappears into the sky. The squiggle turns out to be a road which makes heads spin and stomachs churn before you've even begun your ascent. Yet where local construction workers have co-operated with friendly invisible spirits there's no cause for concern. Safely at the top of the pass, you are rewarded with fantastic panoramic views. Then comes the descent. The road running down to the sea seems to lose itself, hugging the precipitous curves and almost disappearing into the rock. Just as you thought your heart-stopping plunge would never end you reach the bay, scattered with a handful of houses, a church – and dominated by a giant crag, the Álfaborg, the legendary seat of the elf queen. Even if most of us will never be lucky enough to catch a glimpse of her miniature majesty, her jewels are proudly displayed for all to see – as colourful, semi-precious minerals set into the cliffs. If this bewitching spectacle still hasn't convinced you that the little people really exist, then there's always the altarpiece in the little church which depicts Christ preaching the Sermon on the Mount – at Álfaborg.

Above right:
The „Edda" is full of fantastic tales of people with magic power who can command Iceland's invisible powers that be.

Right:
According to popular belief, trolls are ugly and stupid but also honest. The word »trölltryggur« literally means »as honest as a troll« and is still used today. Trolls still out at the break of day are turned to stone.

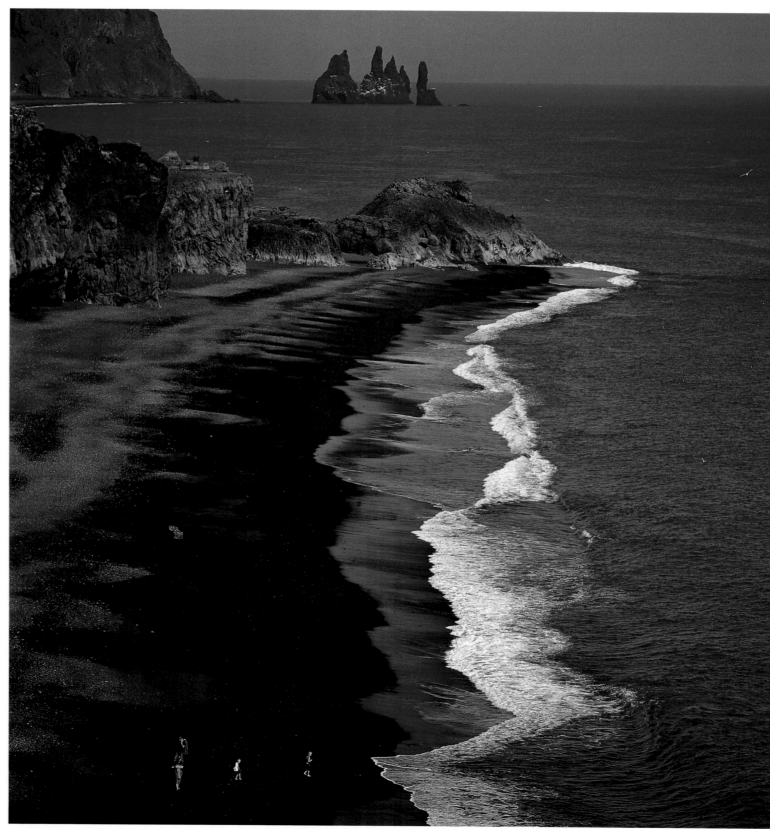

Lava beach near Dýrho-laey, whose name »door hill island« is derived from the natural arch washed into the cliff by the sea. In fine weather you can travel under it in a boat – but not between May 1 and 25 June, when visitors might disturb nesting birds.

Dýrholaey was created by a submarine volcanic eruption around 80,000 years ago. The former island – now linked to the mainland – is surrounded by black beaches of lava and dominated by its lighthouse, erected in 1910.

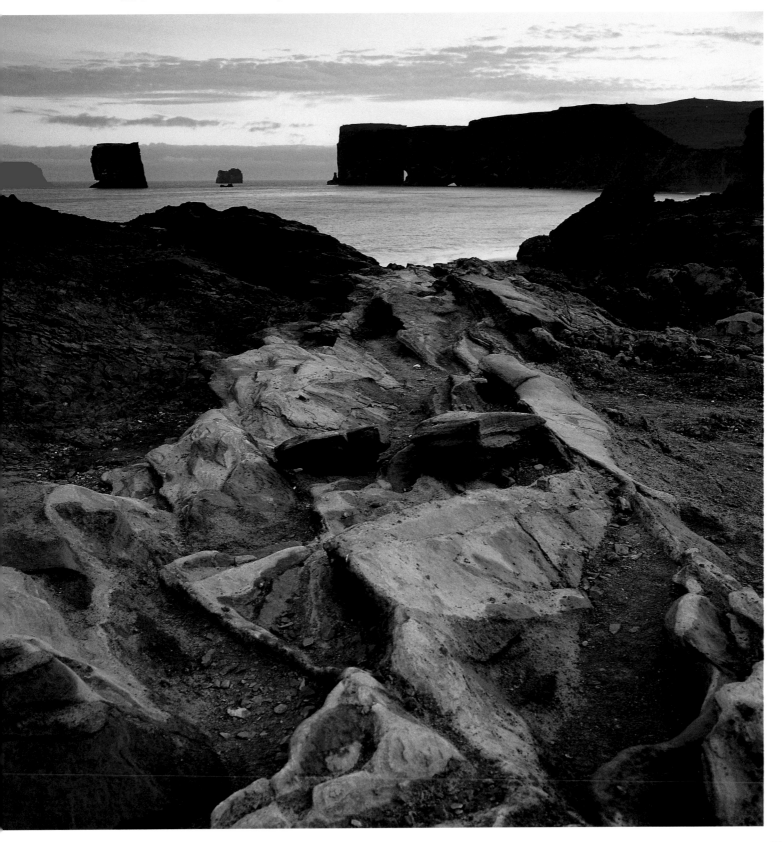

Below:
The number of birds native to Iceland is unusually large for the Northern Hemisphere. From a total of 300 around 70 nest on the island.

Puffins have the penthouse suites in the coast's cliffs, building their nests high up in self-dug miniature caves or rabbit burrows long abandoned by their owners.

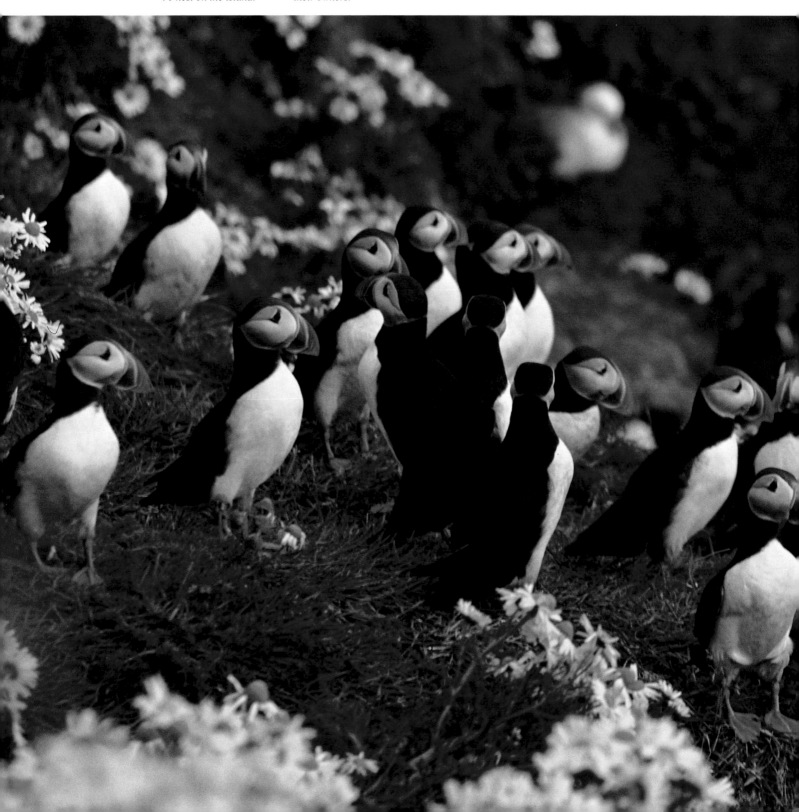

Top right:
...kua nest not only in cliffs but also along flatter stretches of coastline and ...urther inland. For centu-...ries the meat and eggs of all species of gull were valuable foodstuffs. The oily flesh was also used as fuel.

Centre right:
Young coastal tern or sea swallow. Similar to gulls, these black-headed, red-billed birds attack any-thing which comes near their nesting colonies, humans included.

Bottom right:
Iceland is the ornithol-ogist's delight, with its copious variety of inland and coastal inhabitants. Specialist knowledge (or a good bird book) is needed to accurately distinguish all of the country's many winged vertebrates.

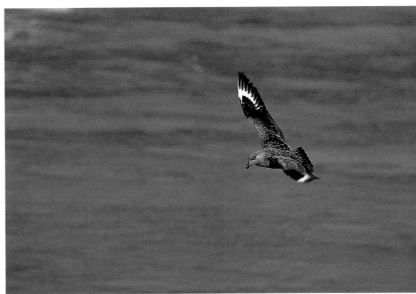

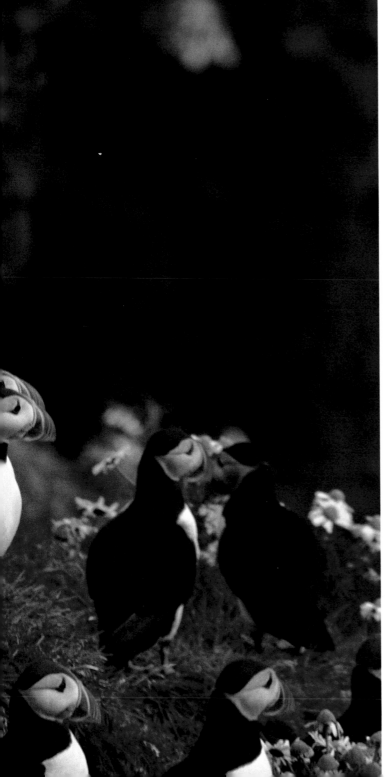

Right:
One of the best viewing points along the south coast is Dýrholaey with its cliffs, not far from the Ring Road.

Below left:
Each year further sections of the Ring Road are tarmacked over. The famous unmade dirt, lava and sand tracks are now only found in the east of the island.

Below right:
For those taking their own car to Iceland – this 2CV has come from Aschaffenburg near Frankfurt – the journey is a long one. Even the shortest ferry crossing takes five days.

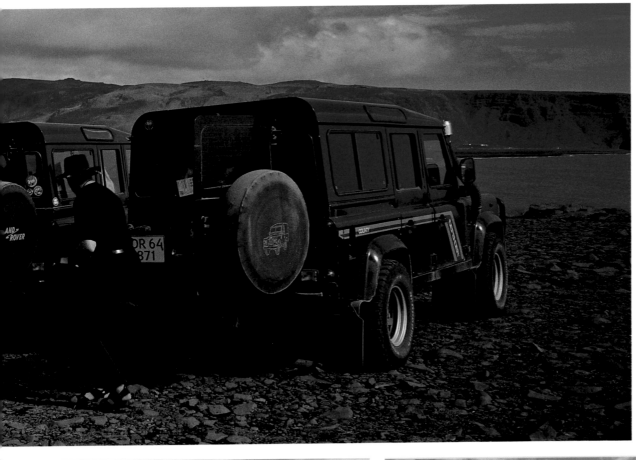

Below left:
The tarmacked sections of the Ring Road also require careful driving. Fairly narrow, with plenty of steep curves up hill and down dale, it's imperative that you read the road and drive slowly. Would-be racing drivers would not be happy here.

Below right:
The icy fingers of the Síðujökull feed the mighty glacial River Hverfisfljot which flows into the sea at Hvalsíki.

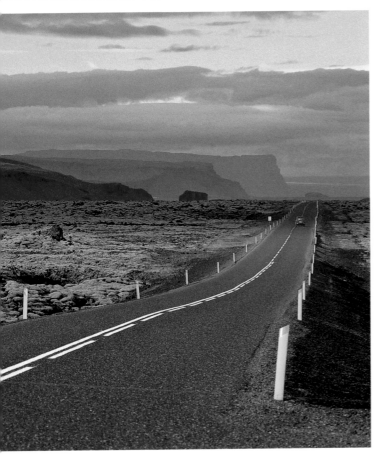

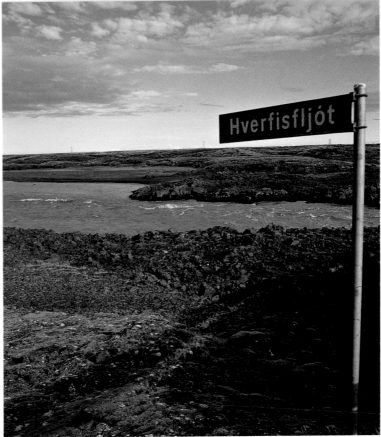

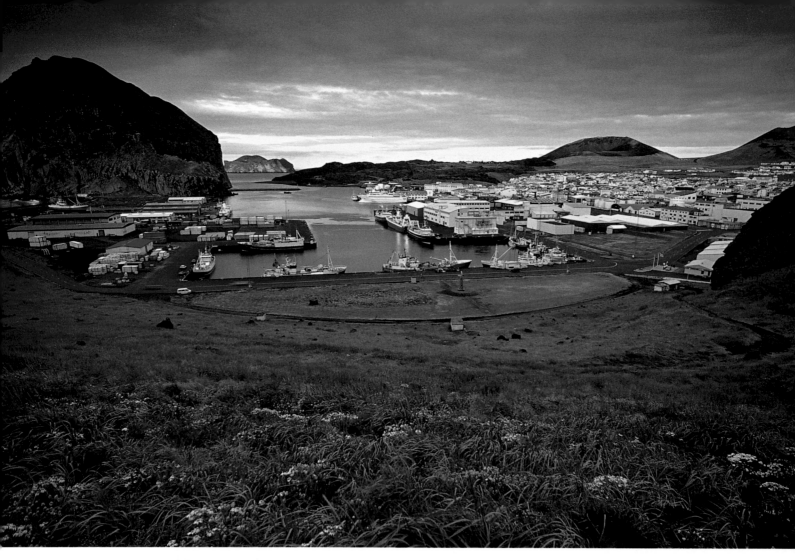

Above:
The harbour in Heimaey on the Westman Islands. Beyond it is the new volcano of Eldfell, whose fierce, five-month eruption in 1973 necessitated the evacuation of the 5,300 inhabitants and greatly threatened Iceland's biggest fishing port.

Right:
During the volcanic catastrophe of the 1970s around one third of the island's houses were destroyed and the rest cloaked in thick black ash. Luckily nobody was hurt. Most of the inhabitants returned to the island and now process 10% of Iceland's total fish exports. In the background are Eldfell and Helgafell.

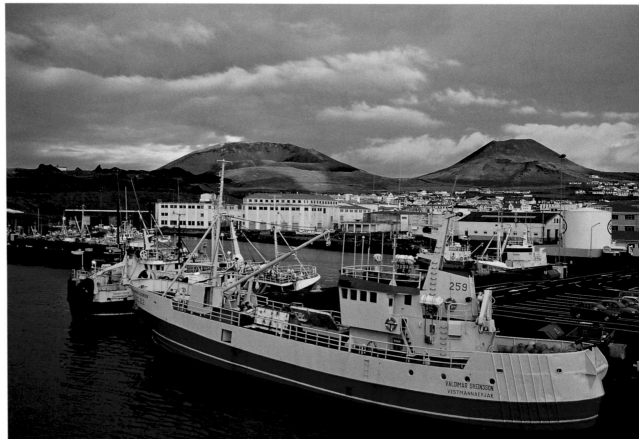

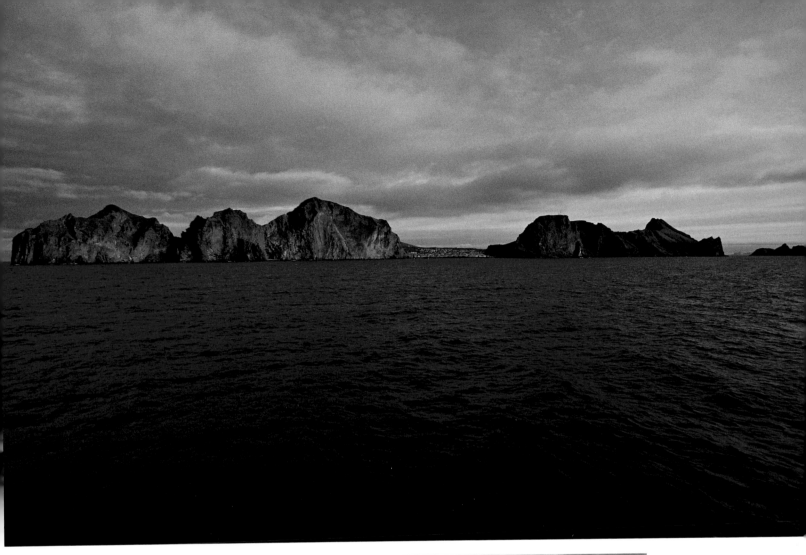

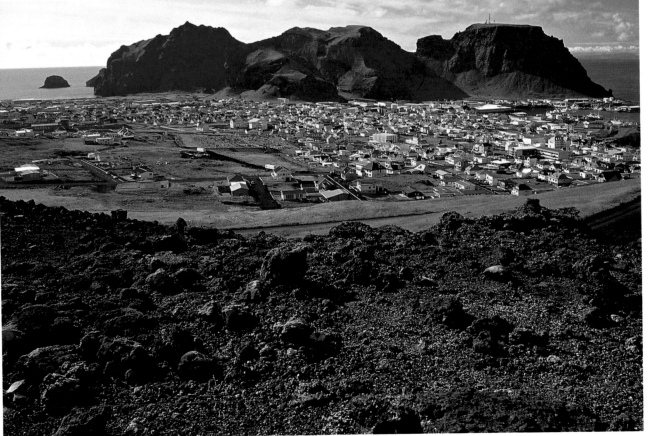

Above:
There are 15 Westman Islands and as many skerries. The first official settler came here in c. 900. To date Heimaey is the only one of the islands which is inhabited.

Left:
View from the »dormant« volcano of Eldfell (227 metres/745 feet high) of Heimaey. The lava stops just short of the first houses.

Below:
*The fishing industry is
Iceland's main branch of
the economy, accounting
for two thirds of the coun-
try's export capital.
Chief clients are the USA,
Europe and Japan.*

Top right:
*At a fishery in Heimaey,
one of the Westman
Islands. The 200-mile zone
provides Iceland with
760,000 square kilometres*

*(ca. 290,000 square miles
of fishing grounds. To sto
the fish population bein
totally decimated, eac
year the government se
a strict fishing quota*

Centre right:
lthough in the 1990s two
fish plants had to close
own, Bolungarvík is still
one of the main fishing
ports in the country.

Bottom right:
Iceland's fish processing
industry – here a plant in
Heimaey – may make use
of the latest technology
yet humans have not been

made entirely redundant.
Most of the fish processed
here are either cod, rose-
fish, haddock, pollock
or Arctic char.

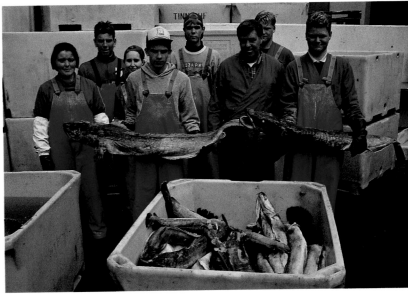

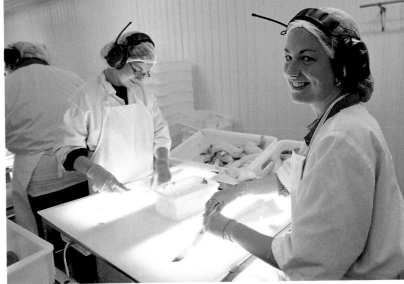

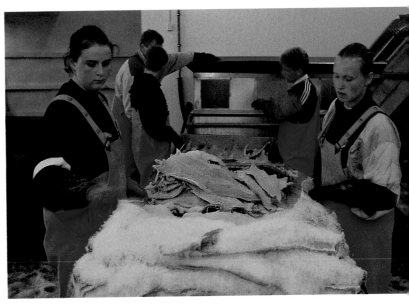

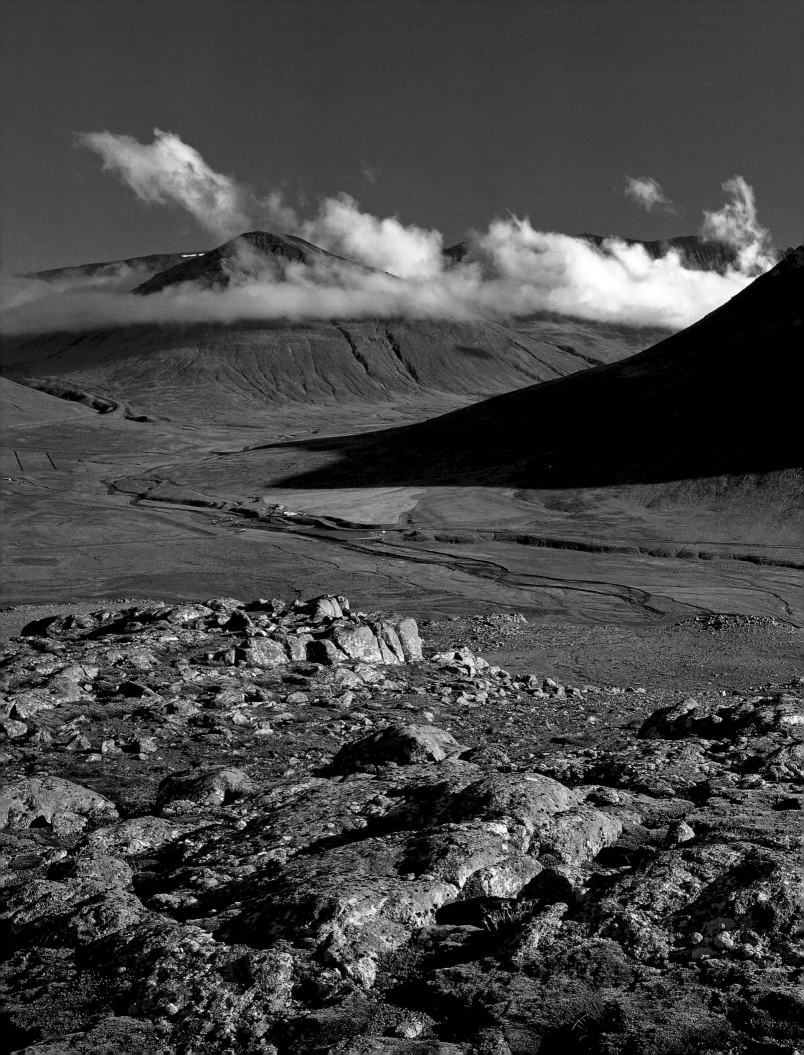

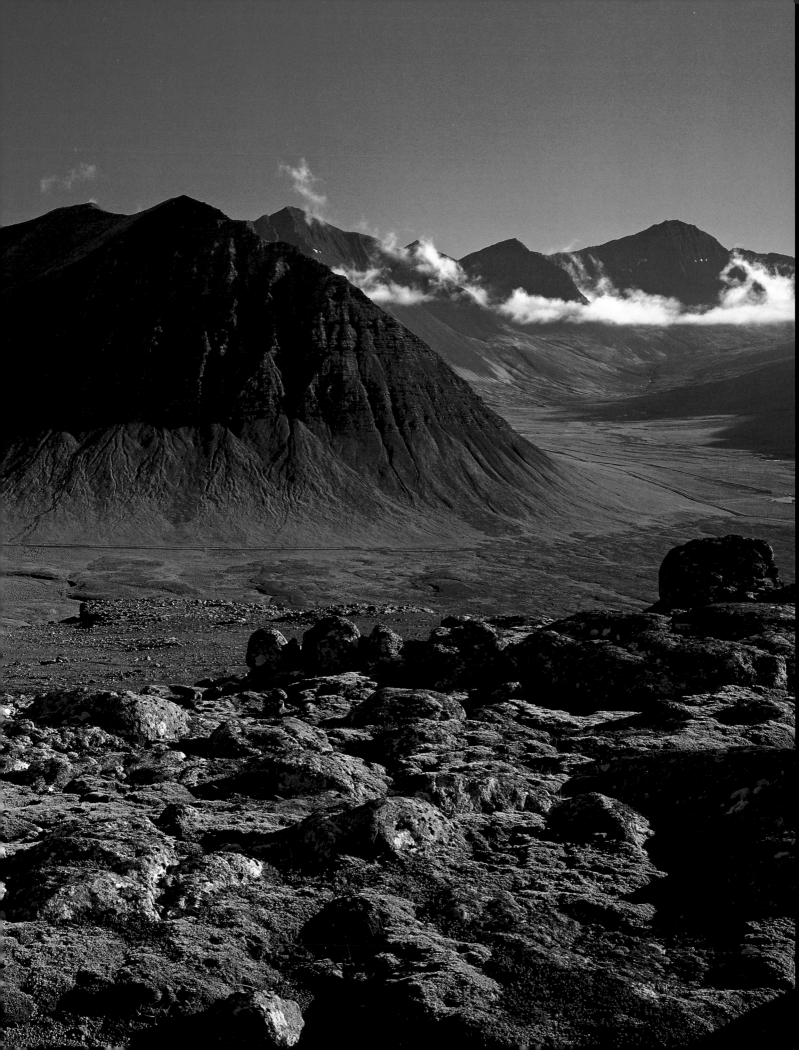

Page 60/61:
The countryside around Dýrafjörður. The fjord is very narrow and ca. 40 kilometres (25 miles) *long. Near the sea vegetation is scarce; further inland grass and moss smother the rocky substrate.*

View of Þingeyri on Dýrafjörður. Once a bustling centre of trade and place of jurisdiction, this little hamlet on the banks of the fjord now num- *bers 500 inhabitants. Today it's a popular base for hikers setting out on tours of the »Alps of the Westfjords«.*

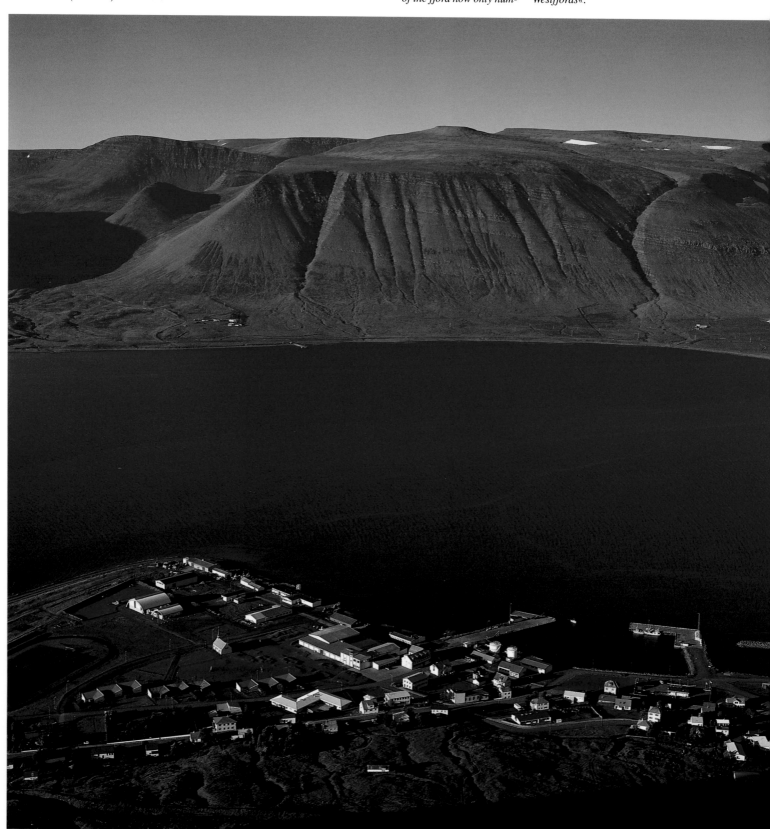

Arnarfjörður near the village of Hrafnseyri. Although not far from Þingeyri, the journey between them involves *negotiating a precipitous pass road which is not without its hazards in bad weather.*

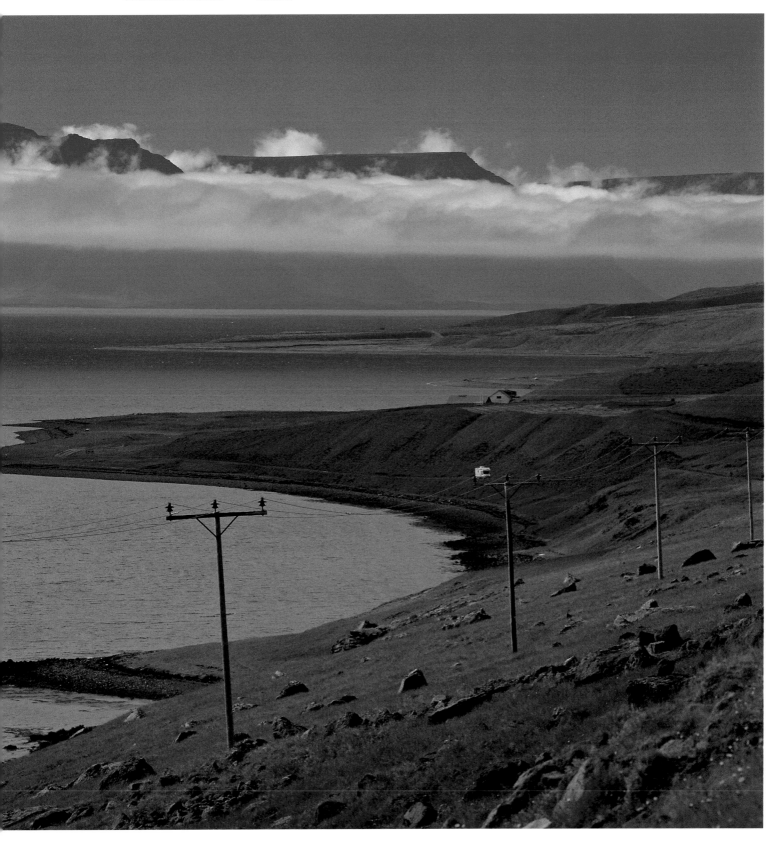

GODS AND HEROES –

»Ragnarök« is the Old Norse term for the end of the world of gods and men. Three years of embittered fighting culminate in the sorry demise of mankind and the deities, a time of terror ruled by the axe and the sword, the wind and the wolves. Sons do not spare their fathers nor fathers their sons. The gods assassinate each other and set the world aflame, headed by the fire giant Surt who introduces the new and terrible war tactic of scorched earth.

Yet after this blazing inferno a new world emerges from the sea and a new sun rises in the sky. The two people who have survived this trial by fire, feeding on the morning dew, now come out from their place of hiding and sire new dynasties who know no suffering, need or evil but innocence and joy.

»Then the Lord will / rule / God almighty on high / the Lord of all« is how this new world is described in the »Edda«, one of literature's great ancient collections of verse. The songs of gods and heroes contained therein date back to the 8th to 12th centuries, with some thought to be even older. The anthology was only unearthed ca. 350 years ago by the bishop Brynjólfur Sveinsson. As he began to unravel the words of the anonymous manuscript, he made an amazing discovery. He already knew of some of the characters and events from Snorri Sturluson's »Prose Edda« which originated in ca. 1220 and was familiar

to the scholars of the day. The manuscripts which later became known as the »Poetic Edda« were obviously the originals on which the »Prose Edda« was based.

Above:
The most important utensil belonging to Thor, the ancient Nordic god of thunder, was his hammer. The illustration shows a bronze talisman hammer found in the south of the country.

Below:
Egill Skallagrímsson – here in a drawing from the 17th century – was both poet and hero of the sagas. His literary prowess is said to have saved his skin; on being sentenced to death by the king of the Vikings, he promptly composed a hymn of praise which earned him a royal pardon.

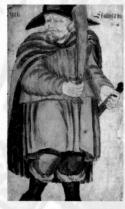

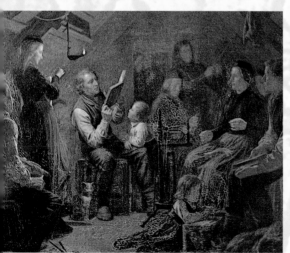

Left:
Icelandic family reading sagas. The painting is from 1861 and now on display at the national museum in Reykjavík.

Further discoveries have been made through Sturluson himself. From him we learn of the skalds, a kind of Norse troubadour who recited their poems at the courts of the land. Unlike the creative minds behind the »Edda«, who are destined to remain anonymous, their names are known to us. The most famous of them was Egill Skallagrímsson, whom we also meet in the sagas, Iceland's second major contribution – with the »Edda« – to early literature.

SAGAS – HISTORY IN MYTHS

Largely penned in the 13th century, these pieces of prose narrate the bloody conflicts which ravaged the first hundred years of the free Icelandic state. Murder, manslaughter and war were common instruments in the battle for power. That these tales have retained their great significance down the centuries – ingrained in the minds of the Icelanders in the tiniest detail – is primarily due to the fact that today the country speaks more or less the same language as it did in the Middle Ages. Another important factor is that many of the places where the stories take place can still be precisely located. One of these is the Borg á Mýrum farm on the edge of Borgarnes which belonged to the aforementioned Skallagrímsson and his family. The name Alftafjörður (Swan Fjord) goes even further back to the time of the Settlement. Situated in the southeast of the country,

from the date of the first peopling of Iceland to the present day – over 1,000 years – the fjord has been famous for its colony of whooper swans.

With so many genuine places placing these narratives in a feasible context, it's not surprising that for a long time the Icelanders took their sagas at face value, confusing fact with fiction and becoming »imprisoned by the written word«. This allegation was made by someone who should know what he's talking about: Nobel Prize winner Halldór Laxness. His novel »Iceland's Bell« (1943/1946), a small country's big contribution to the greats of world literature, has not only been translated into two dozen languages but is hailed by his fellow countrymen as a national modern epic. Both the subject matter and themes of the book consciously tread in the footsteps of the ancient sagas. One of the major characters, scholar Arnas Arnaeus, has all the traits of the legendary professor Árni Magnússon, who spent his life indulging his passion for sniffing out old manuscripts and saving them from destruction and decay. And as with the sagas any search for actual places where the tales are set will be richly rewarded. We will be familiar with the deserted farmhouse at Sænautavatn, for example, from »Winter Night on the Jökuldalsheiði«; the turf hut Hvalnes on the east coast was where »Paradise Reclaimed« was filmed. The bell itself, the namesake of Laxness' award-winning novel, is a 1,000-year-old gift from King Olav of Norway and hangs in the church at Þingvellir.

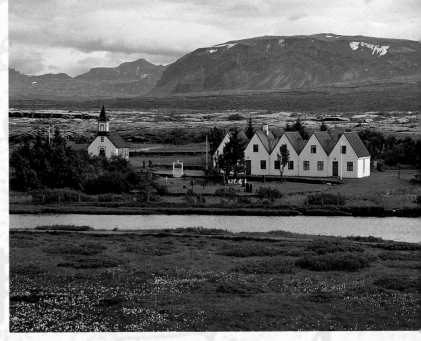

Right:
At the yearly two-week session of the Alþingi in Þingvellir laws were made, sentences passed and sagas read and performed, ensuring that the ancient tales passed from generation to generation.

Left:
Medieval manuscripts tell the tale of the sagas of Iceland, of Nordic kings, valiant heroes and gallant knights in shining armour.

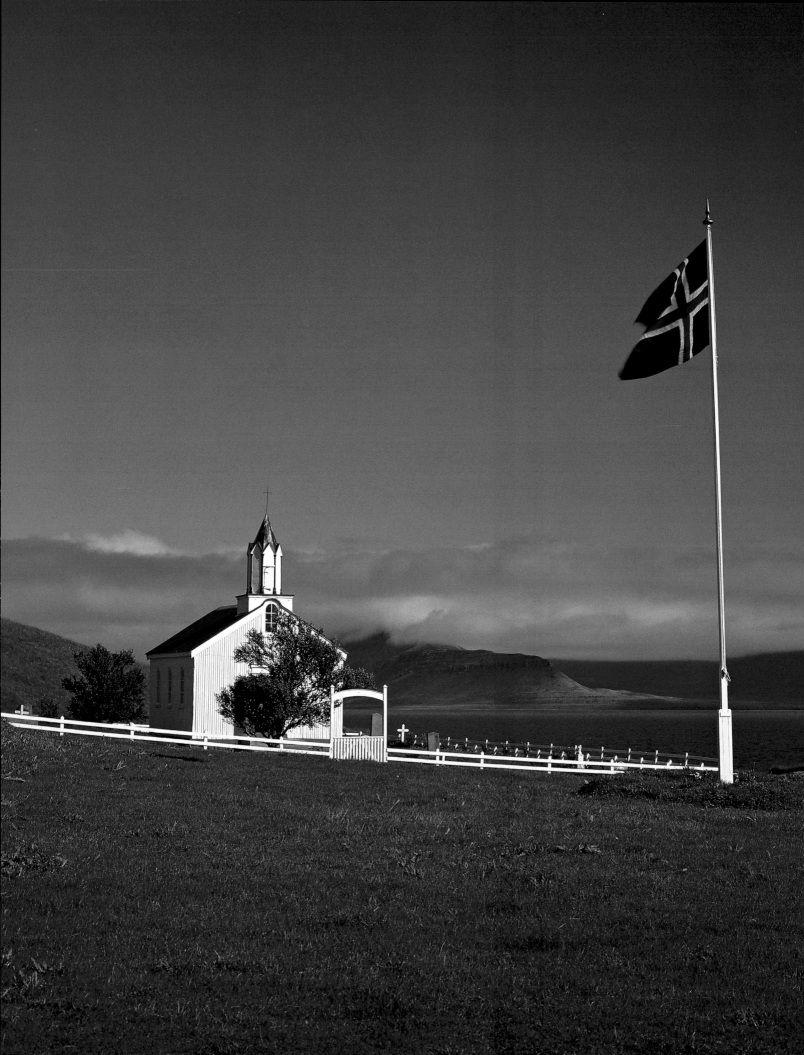

ft page:
urch in Hrafnseyri.
e old vicarage holds
eat significance for
e history of Iceland.
is named after Hrafn
einbjarnarson.

Below:
Hrafnseyri is also the
birthplace of Jón Sigurðs-
son, the father of Icelandic
independence. The house
where he was born, around

200 years old, has been
lovingly restored and, like
the local museum dedi-
cated to his life and work,
is well worth a visit.

Below:
Blönduós bathed in the
light of the setting sun.
With just 1,000 inhab-
itants, the little village
straddling the glacial

Blanda River in the north-
west of the country was
established 1,000 years
ago. It was granted har-
bour and trading rights
in 1876.

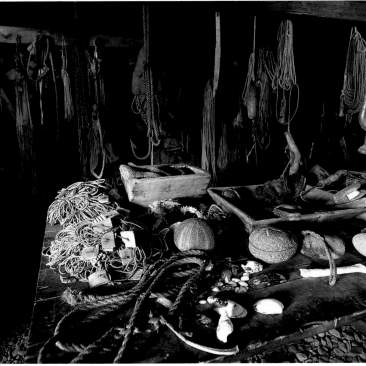

Above left and right:
The restored Ósvör fishery
in Bolungarvík documents
the harsh living and

working conditions of the
island's fishermen. Ósvör
fishery provided accom-
modation for the crews of

two fishing boats and
various outhouses for nets
and tackle. Much of the
original complex and

equipment, dating back
to the beginning of the
20th century, has been
preserved.

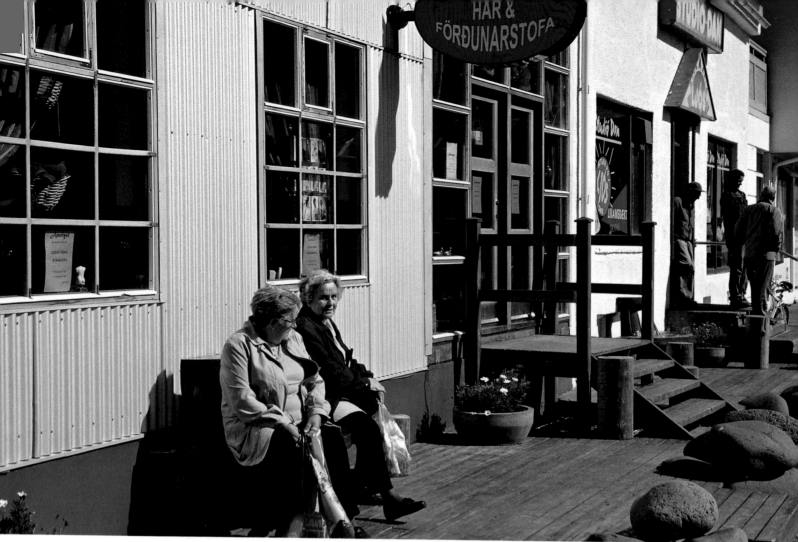

Above:
With 3,000 people living here, Ísafjörður is the largest town in the north-west of Iceland. In the 16th century it was an important centre of trade controlled by the Hanseatic League. It was granted its town charter in 1866.

Right:
The »Landnámabók« names Helgi Hrólfsson as the founder of Ísafjörður. The name of both the fjord and village of Skutuls-fjörður (Harpoon Fjord) is also attributed to Hrólfsson. His farm once stood on the Eyri spit.

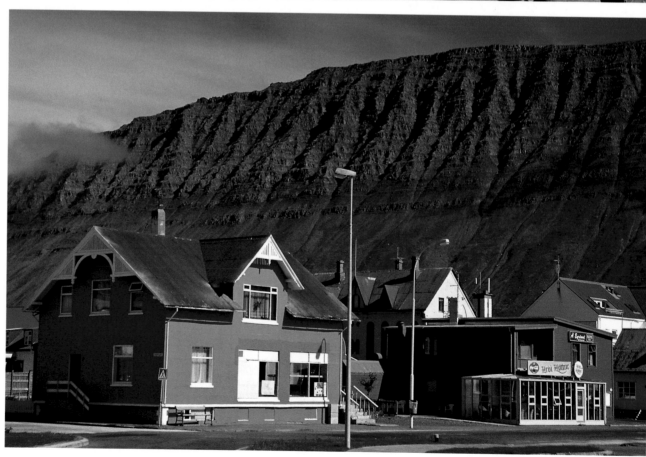

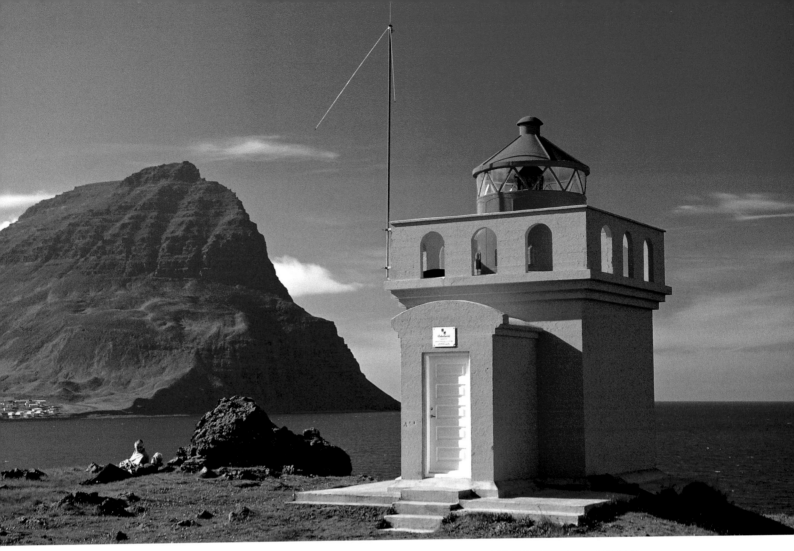

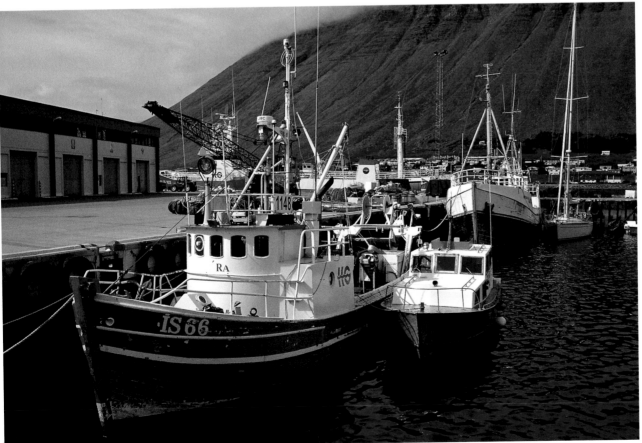

Above:
The brilliant orange of
the lighthouse near
Bolungarvík stands out
against the blue skies
above the oldest and most
northerly place of settle-
ment in the Westfjords.

Left:
Sheltered on all sides,
the harbour town of
Ísafjörður provides a
safe haven for its fleet of
fishing boats. The local
shipping museum de-
scribes what life was
(and is) like for the people
living in the Westfjords.

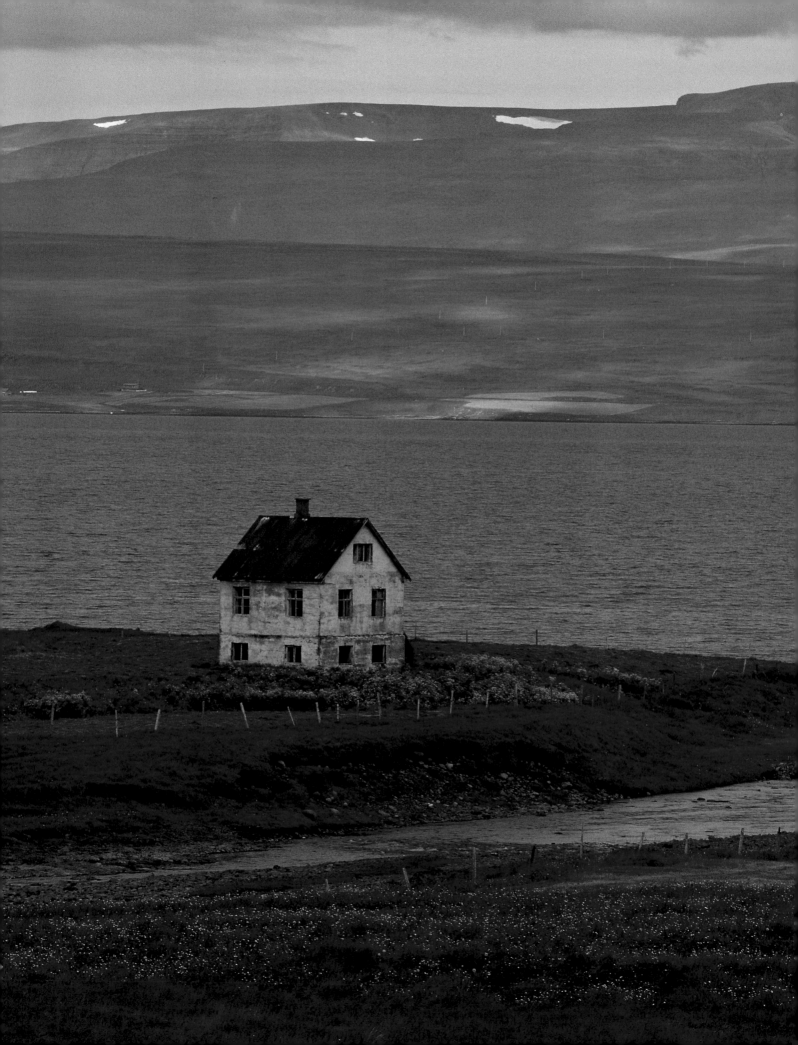

Left page:
*abandoned house on
rútafjörður in the
orthwest of the country.
migration to the cities
as always been a*

*problem in Iceland. As
idyllic as the setting might
seem, the disadvantages
of living in rural isolation
often outweigh the advan-
tages.*

Below:
*Salmon fisherman in the
Westfjords. The season
runs from June 20 to the
middle of September. Fish-
ing permits are required,
obtained from the National
Angling Association.*

Below:
*Lava rocks on Hestfjörður.
The long, narrow fjord is
the twin of Seyðisfjörður,
the two separated by a
peninsular and the im-
pressive Hestur Mountain.*

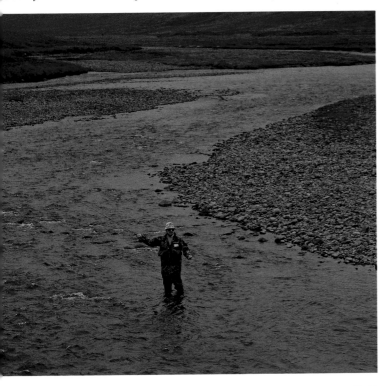

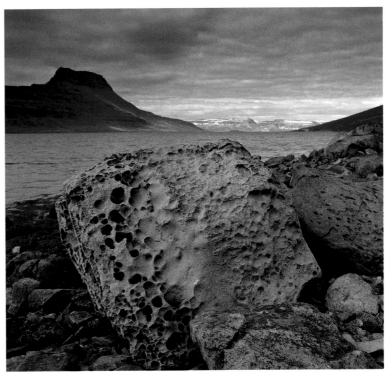

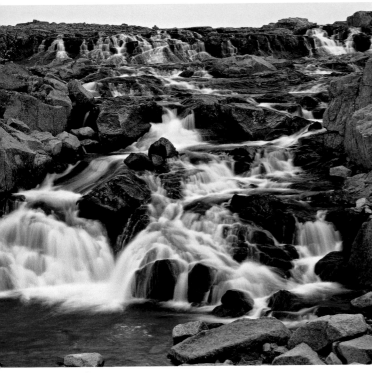

*This magnificent waterfall
tumbles right down to
Route 61 in the Westfjords.*

*The best place to catch
salmon in Iceland is the
River Laseá. Other spots,
such as the mouth of the*

*enormously long River
Blanda in Blönduós,
shown here, also promise
rich pickings.*

The River Blanda near Blönduós. Not far from the village is one of Iceland's important historical sites: the monastery of Þingeyrar. Established in 1133, it was the first in the country and the place where many of the sagas were originally notated.

Frozen river near Varmahlíð. This is where many of the events in the sagas took place, such as the great battle of medieval Iceland, fought near the now deserted Haugsnes Farm in 1246.

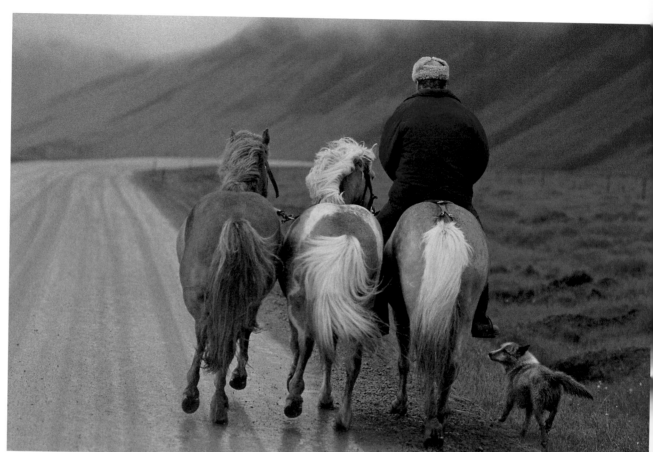

Right:
Besides the thoroughbred Arabs there is no other species of horse which has remained as pure bred over the centuries as the Iceland pony. The breed is directly descended from the fjord ponies introduced by the first settlers, their pedigree guaranteed in as early as the 10th century by a ban on all imports of horse.

Below:
1,000 years of isolation have helped preserve the unique characteristics of this tough little horse which can survive the long winters out in the wild. Spring brings greener pastures and friskier temperaments to these ponies grazing near Hvalfjörður.

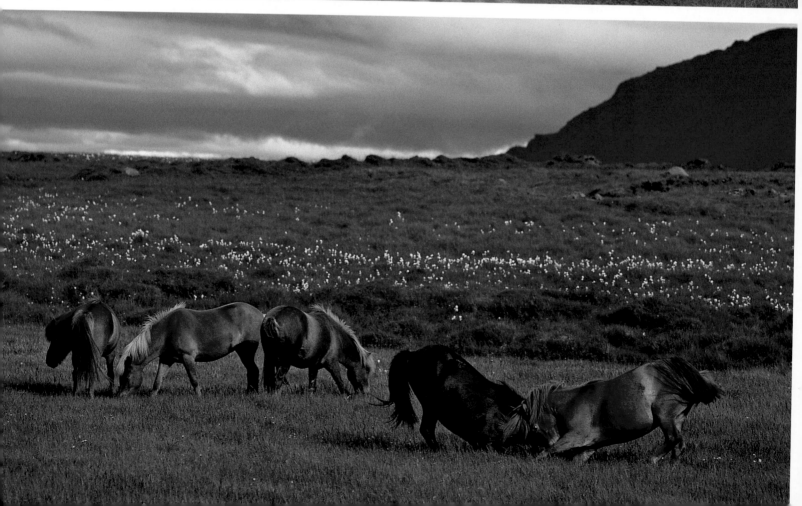

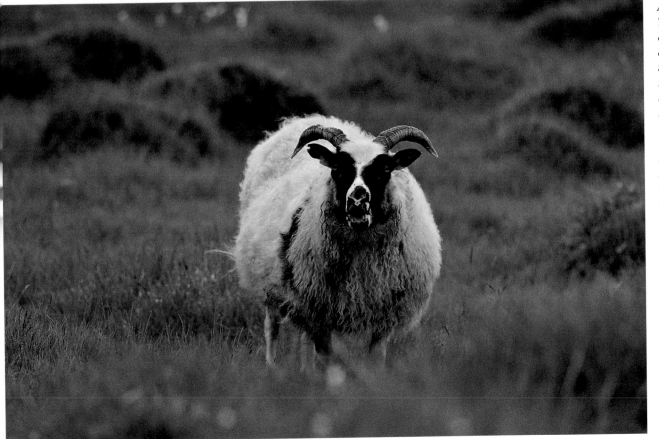

Above:
There are approximately
80,000 Iceland ponies
on the island; Germany
now has around 30,000.
Even today animals which
have been exported are
not permitted to re-enter
the country.

Left:
Another tough customer
is the Iceland sheep,
the staple of the farming
industry in Iceland and,
together with the island's
many fish, also a staple in
the kitchen. The meat is
smoked, salted and made
into sausages; another
regional speciality is the
singed sheep's head which
is not for the squeamish ...

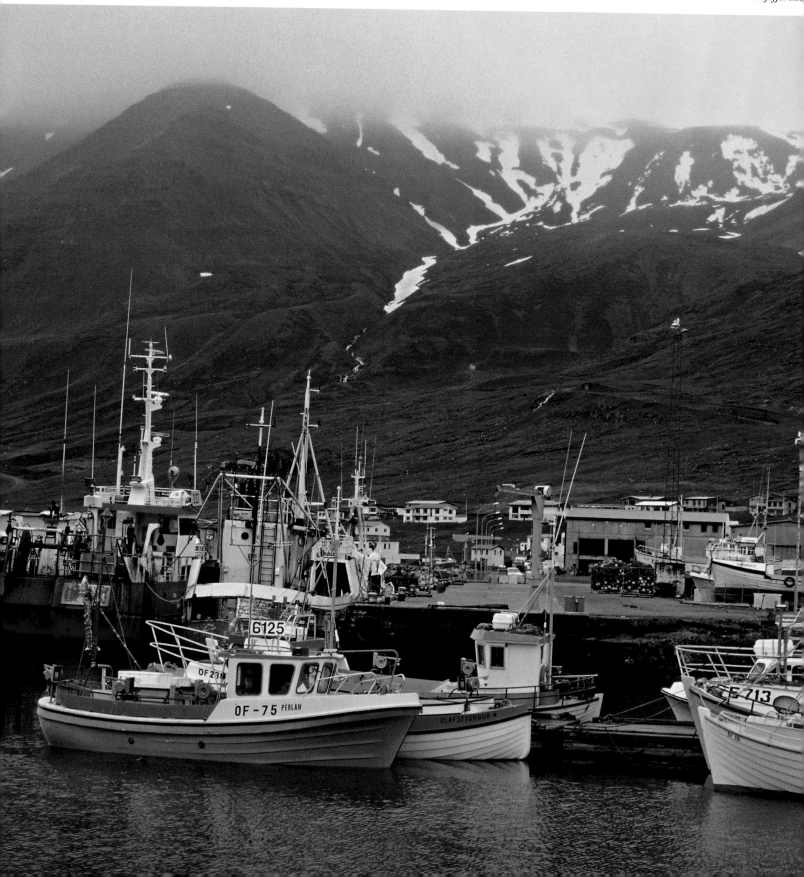

Below:
Ólafsfjörður on the north
coast, riddled with fjords,
is dominated by its mighty
mountains whose peaks
are capped with snow all
year round. Its 1,000-odd
inhabitants live from fish-
ing and fish processing.

Top and centre righ
Even Ólafsfjörður
trawlers need repairin
now and again. Once se
worthy, the professiona
head out to their fishin
grounds in the Atlanti
with Lake Ólafsfjarda.

vatn south of the little own reserved for anglers. The lake mingles with water from the nearby sea, providing fishermen with a variety of salt- and freshwater fish.

Bottom right:
Young woman from the Westman Islands. Women have played an important role in the history of Iceland since its begin- ning; more recently the country has honoured this tradition by electing the first female head of state in the world.

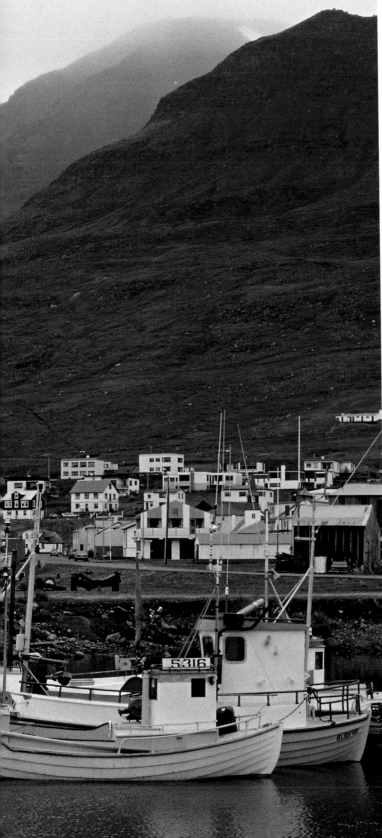

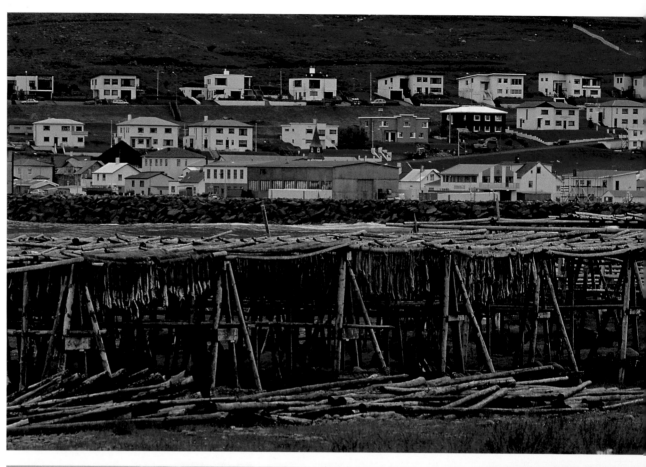

*View of Ólafsfjörður.
Iceland's number one
export, dried and salted
fish, has now dwindled
in importance so much
that wooden drying racks
such as these are an ever
greater rarity.*

*Wind and sea currents
have driven these wooden
posts all the way to
Steingrímsfjörður from
Siberia.*

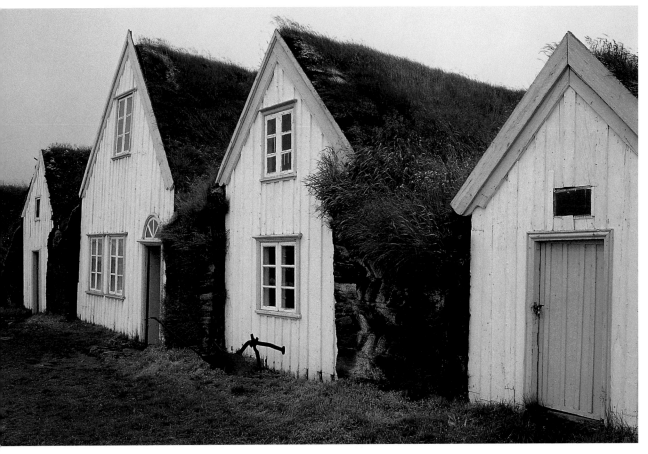

The best-known and most interesting open-air museum in the country is the one in Glaumbær. The original turf hut, which was still inhabited around 50 years ago, has since been joined by a number of other historic buildings.

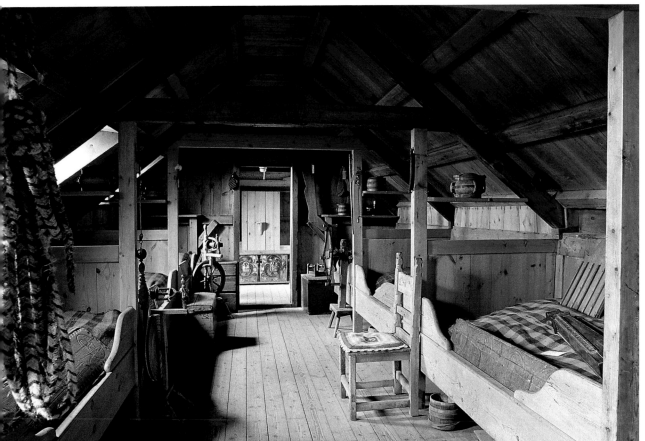

The old farmhouse in Glaumbær has walls of turf, with just the front facade clad in wood. Many of the furnishings are from the 19th and 20th centuries.

THE LAST BASTION OF THE UNMADE

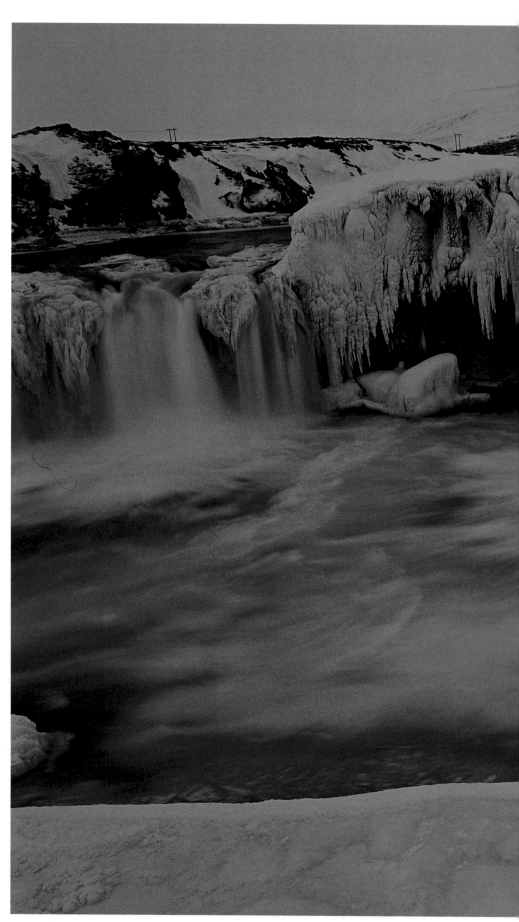

The Goðafoss in winter white. Despite its Arctic location and chilly name Iceland, warmed by the Gulf Stream, is actually much milder than you might think. The weather is, however, extremely fickle. As one local saying goes: »If you don't like the weather, just wait; it'll soon change.«

If you're looking for those infamous sections of Ring Road which haven't yet been tarmacked over, then this is where you'll find them. Mind you, you'll be in for a rough and bumpy ride, through 100 kilometres (60 miles) of solitary, mountainous desert between Egilsstaðir and Mývatn, almost totally devoid of vegetation – yet anything but boring. It's like being up in the highlands or the Alps. When after miles and miles of fascinating scenery a lonely farmstead appears on the horizon, the only one on the entire journey, it's almost impossible to believe that it's not a mirage but a genuine »fjallakaffi«, a mountain hut-cum-café.

Back to Mývatn. The lake and its environs really are breathtakingly beautiful. All that's missing are the glaciers. Despite this the lake is the second-most popular destination after Reykjavík – and also an excellent place from which to embark on forays out into the east of the island.

Superlatives abound here in the east. Jökulsárgljúfur National Park, for example, has the longest river canyon in Iceland. 25 kilometres (15 miles) long and up to 100 metres (328 feet) deep, the gorge is a must with its fascinating basalt rock formations punctuating one waterfall after another. In Húsavík you have the best chance of spotting one of the giants of the sea (and of a grand trip out onto the ocean) from one of the many observation points, while at the Melrakkaslétta Peninsular the Arctic Circle is the closest to the mainland at just 3 kilometres (2 miles).

The icy wastes of Iceland are not found here but to the southeast. The Vatnajökull icecap is up to 1,000 metres (3,280 feet) thick and around 8,000 square kilometres (3,090 square miles) in size. Even its offspring, which it sends slithering down into the valleys or towards the sea, are frequently larger than their Alpine counterparts.

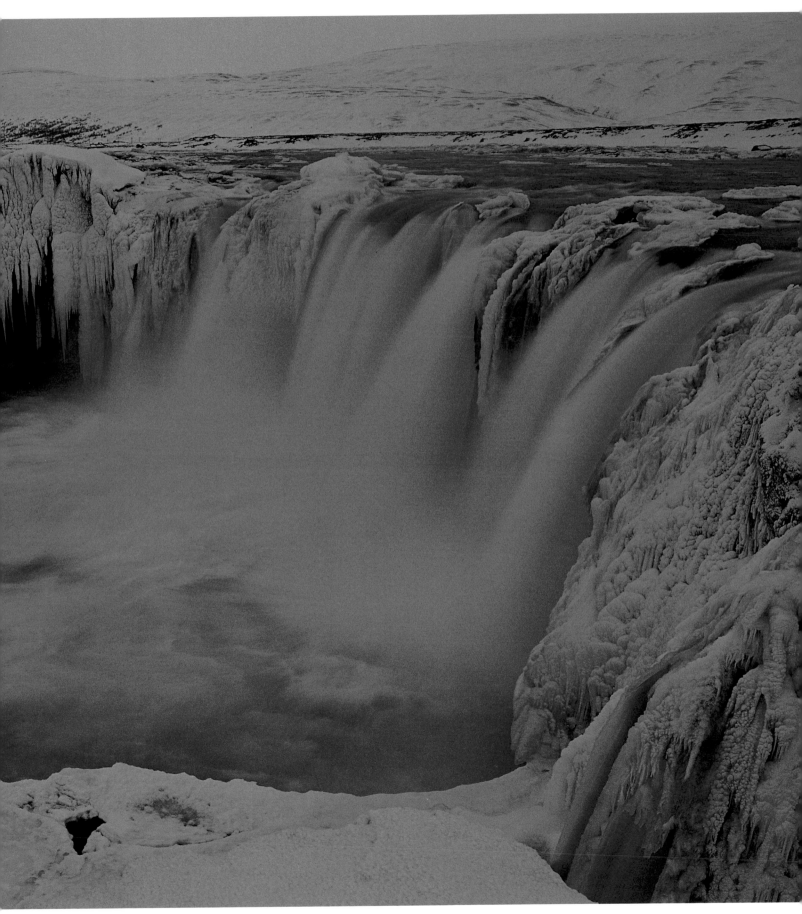

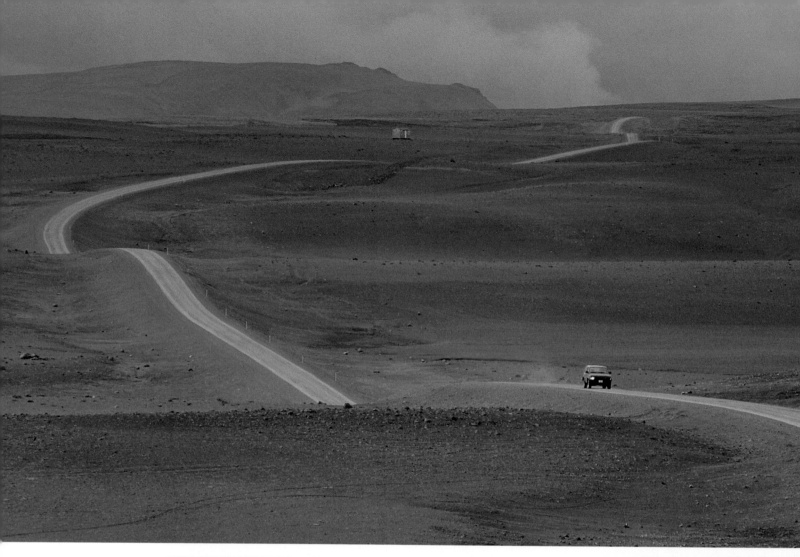

Above:
The long and winding road between Reykjahlíð on the northern shores of Lake Mývatn and the harbour town of Húsavík.

Right:
Surrounded by a desert of rocks and crashing over 40 metres (130 feet) into the depths at a rate of over 200 metric tons of water a second, the Dettifoss is the largest waterfall in the European west. The best views of this breathtaking natural spectacle are from the west bank of the falls.

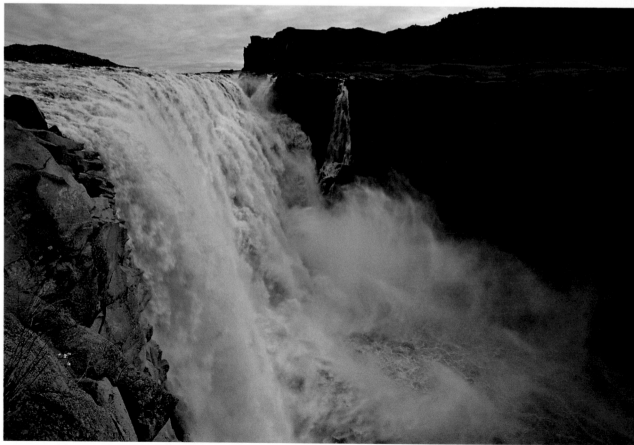

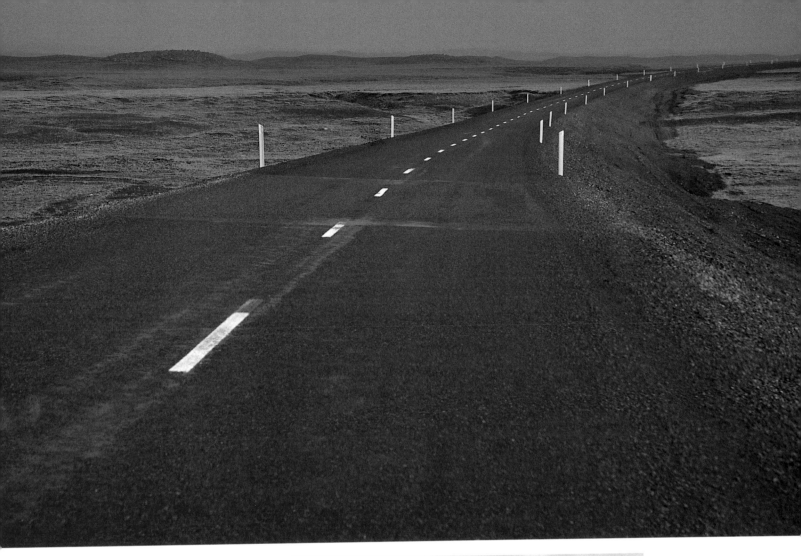

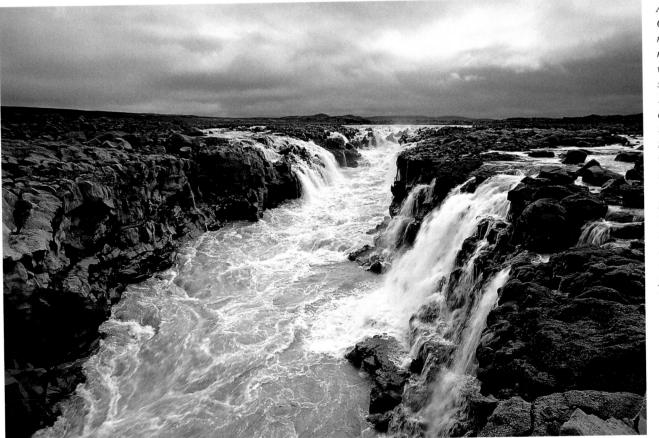

Above:
On Jökulsá á Fjöllum near Herðubreið. The mysterious table mountain with its simply enormous summit crater, almost 1,700 metres (5,580 feet) above sea level, is the »queen of Iceland's mountains« and is said to be where the great god Odin resides.

Left:
The Ring Road northeast of Lake Mývatn. A few miles on at the Grímsstaðir á Fjöllum farm, which doubles as a weather station, a minor road branches off to the Dettifoss, crossing a bridge to the west bank of the waterfall.

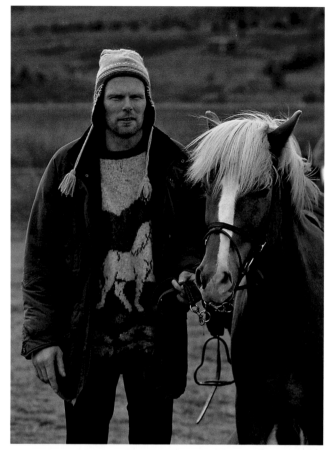

Iceland's horse breeders are proud of their animals – and rightly so. Here they are being shown at the Einarsstaði stud farm in the north of the country. At the country's gymkhanas, where horses and riders demonstrate their various skills, the mood among performers and spectators is decidedly festive, with a good time had by all.

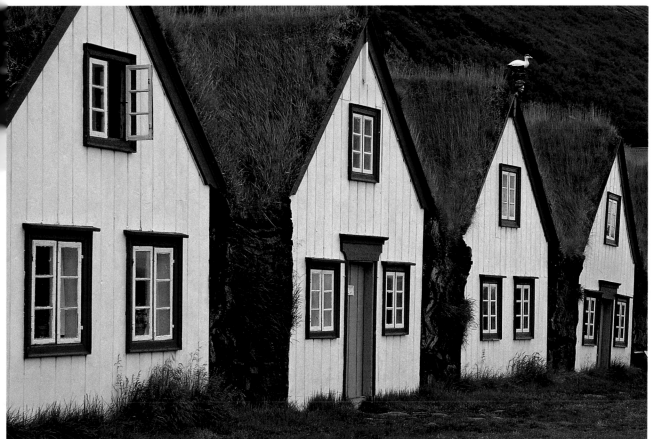

Above:
The church in Laufás
dates back to 1865. It was
built by native villager
Tryggvi Gunnarsson who
later became a bank
manager.

Left:
Built between 1840 and
1870 and inhabited until
1936, the parish of Laufás
is one of the most charm-
ing rural settlements
in the country. Also the
birthplace of poet Björn
Halldórsson (1823–1882),
it is now classified as a
historical monument.

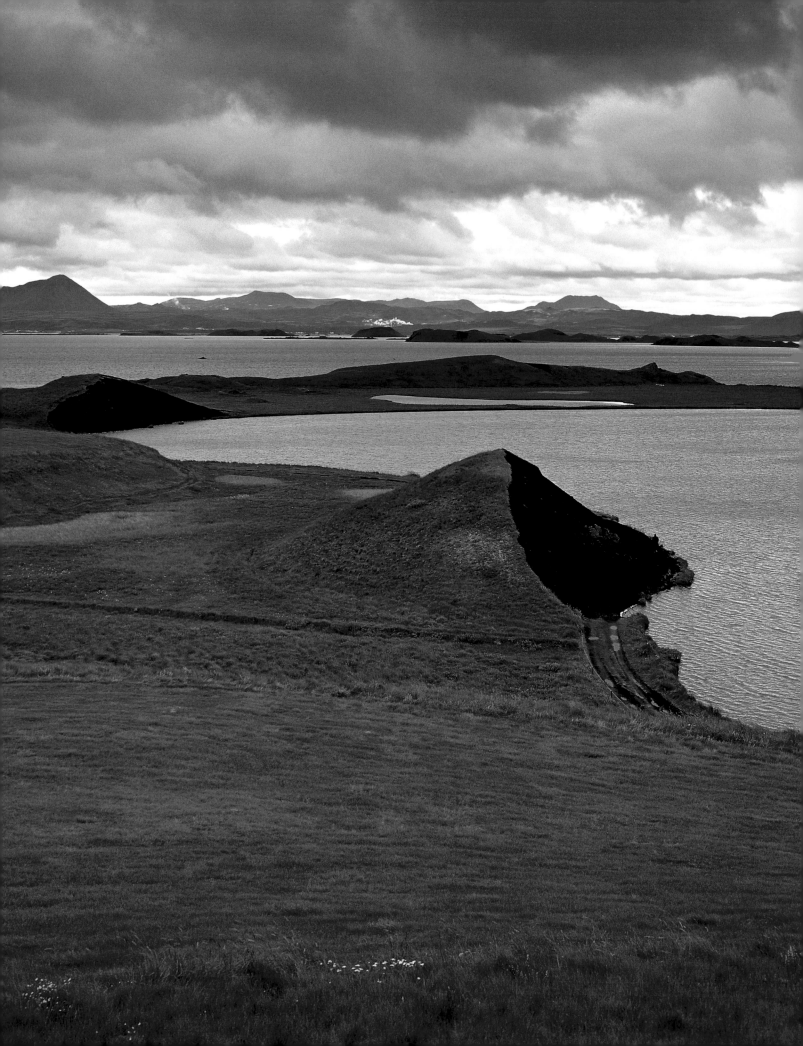

eft page:
*lthough only the fourth-
rgest lake in the country,
ývatn is undoubtedly the
ost famous. People come*

*here in their thousands to
take in the fantastic scen-
ery and the many natural
landmarks nearby.*

Below:
*Mývatn was formed in the
wake of two volcanic erup-
tions 3,700 and 2,000 years
ago. The lake is relatively
shallow, with its deepest
section measuring just
under 5 metres (16 feet).*

Below:
*The name Mývatn or Midge
Lake pays homage to its
swarms of nasty insects
which drive visitors to
distraction but provide
fish and birds with a vital
source of nourishment.*

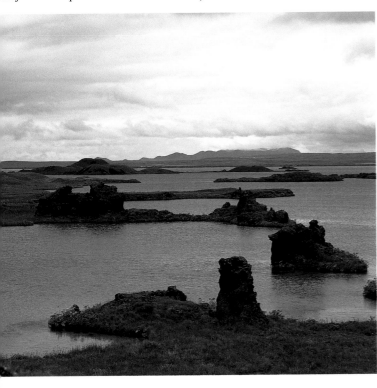

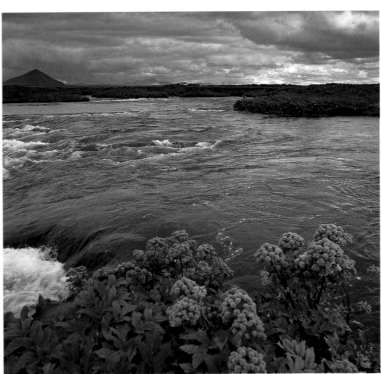

Above:
*The many tiny bays and
miniature islands of the
lake – with Slútnes in the
northwest undoubtedly the*

*most beautiful – provide
photographers and paint-
ers with an impressive
catalogue of motifs and
perspectives.*

Above:
*The Lake Mývatn area in
the verdant green of sum-
mer. The lush vegetation
along its shores provides*

*many species of bird. The
lake is home to all types of
duck native to Iceland –
with the one exception of
the eider.*

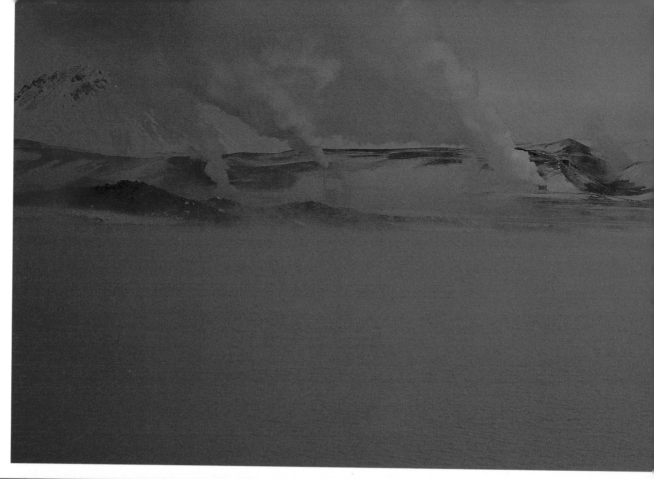

Right:
Winter completely changes the scenery around Lake Mývatn. The solfatara fields, whose brilliant colours glitter in the summer sun, now lie buried beneath a blanket of snow, broken up only by contrasting mounds of black lava.

Below:
Marvelling at the beautiful winter landscape it's easy to forget that beneath your feet the earth is smouldering – dangerously close to the surface. It vents its pent-up aggression in an occasional pillar of steam or patch of meltwater in the otherwise icy surroundings.

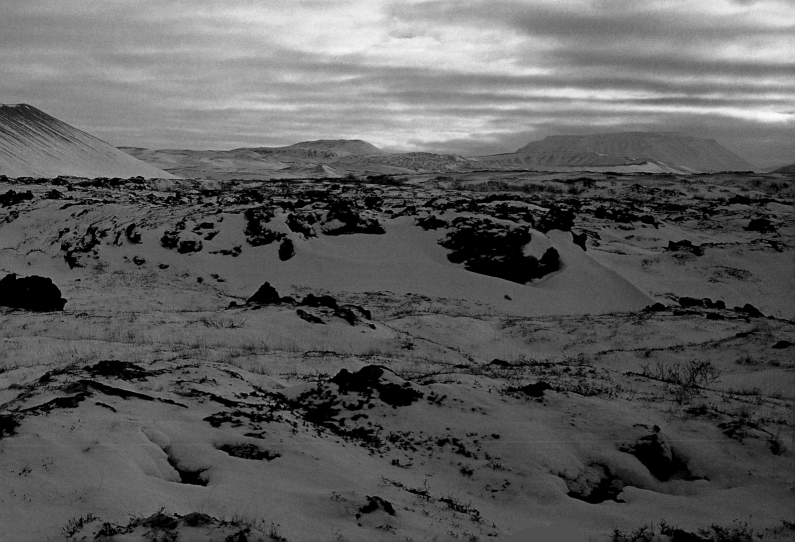

FIRE AND ICE –

If Mother Nature had exercised a little more decorum, Iceland would not exist. Not one but two magma vents erupted simultaneously, spewing liquid rock onto the bed of the sea which slowly amassed until an island was formed. Although this happened 16 million years ago, the earth here has not yet settled. The crust of Europe's youngest stretch of land is obviously not as thick as that of its Continental counterpart and continues to

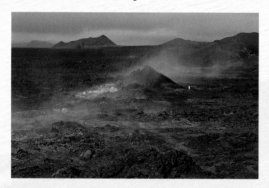

belch fire and boiling water into the atmosphere.

Since the settlement of the island over 1,100 years ago between 250 and 500 eruptions have been recorded, depending on whether prolonged outbreaks lasting months or even years are counted once or twice. Iceland has ca. 200 volcanoes belonging to around 30 volcanic systems which are spread across three major areas. The largest sprawls from the southeast to the northeast of the country, running along the enormous fissure known as the Mid-Atlantic Ridge which nudges the Eurasian and North American plates a few centimetres apart each year. The two other centres of volcanic activity are the Snæfellsnes Peninsular and a region which one can only describe as the fiery heart of southern Iceland. That this area is unable to settle is due to the Hekla – among others – whose activity far exceeds that of all other volcanoes. Devastating eruptions –

such as those at the beginning of the 12th century and particularly between 1766 and 1768 – have helped catapult the fissure volcano to sorry fame. It thus comes as no surprise that early on it was branded the Mountain of Hell, with pious tales told of the legions of the damned roasting in its underground inferno.

This imaginary Gehenna became all too real in 1783/84 when vast amounts of lava, ash and poisonous fumes burst forth from the Laki fissure for over eight months. The consequences were dire; a fifth of the population and two thirds of the country's livestock were annihilated. One natural catastrophe led to another; famine and a desperate struggle for survival outlawed all rules and norms governing an otherwise civilised society. As the devastation and resulting pollution bode ill for the future of the mere 40,000 survivors, the authorities even considered evacuating these unfortunate souls to Denmark.

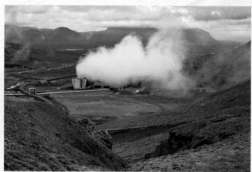

VOLCANIC AND GLACIAL DESTRUCTION AND CREATION

It's not the volcanoes which cause the Icelanders the most headaches, however, but the glaciers. Volcanoes do play a part here too, though; buried deep under the ice, once active they cause the glaciers to melt. This marriage of the elements, of fire and ice, gives rise to violent floods which carve their way down to the sea as raging rivers of mud and rock. There are two volcanoes which are particularly well-known for their subterranean explosions: the Grímsvötn deep under the frozen wastes of the Vatnajökull and »old witch« Katla under the Mýrdalsjökull, who regularly upsets the glacial status quo every few decades. At the (to date) last shake-up in 1918, so much scree was washed down to the ocean that the island grew a few

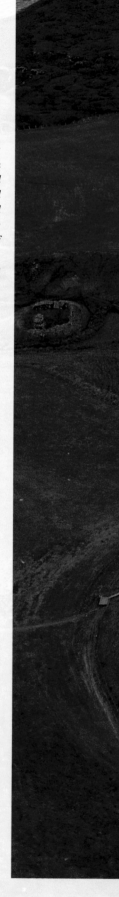

Left:
The natural forces of the earth have fascinated artists for centuries. This old woodcut shows Mount Hekla erupting, once known as the »Gateway to Hell«.

Right:
The pseudocraters on Mývatn. The round depressions were formed when hot lava collided with the waters of the lake, sending rockets of steam up into the atmosphere with such force that huge holes were rented in the ground.

Far left:
The Leirhnjúkur Crater is one of the major attractions in the Mývatn area. It last erupted just two decades ago. A track leads through the middle of the fresh lava which is still hot enough to burn inquisitive fingers.

Left:
At the Krafla central volcano, surrounded by dangerous fissures, in 1977 a geothermal power station went into operation. The constant change in the nature of the emissions makes tapping the earth's natural resources a tricky undertaking.

Far right:
Now that the Great Geyser in Iceland's most famous area of thermal activity has lost much of its former vigour, the Strokkur Geyser or Butter Churn is currently the hot favourite, spewing tall fountains of water into the air every 10 minutes.

ICELAND'S DYNAMIC GEOLOGY

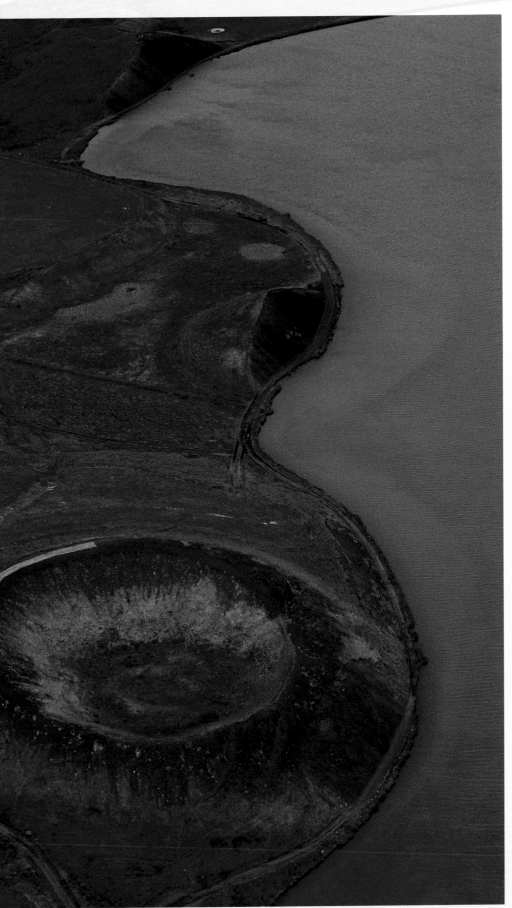

square kilometres in size. Katla herself is related to the table mountain – one example of which is the Mountain of the Gods Herðubreið which dwarfs everything for miles around – a volcano which in its »youth« was encased in a thick sheet of glacial ice subsequently shattered on eruption.

Each of the volcanic forms moulding the face of Iceland has its own history and prize showpiece. The Skaldbreiður, for example, is a shield volcano, the Hverfjall on Mývatn – which also has the most heavily frequented pseudocraters – an explosion crater. The most famous caldera (imploded crater) is the Askja surrounded by the Dyngjufjöll Massif. Snæfell and Hekla are both stratovolcanoes.

The earth's fiery energy is not only destructive; it can also be useful. Nowhere else in the world are there as many hot springs as in Iceland. These provide heating for ca. 80 percent of the population and also fuel the Hveragerði project where flowers and vegetables thrive – albeit under glass – in an Icelandic Garden of Eden. The country's many swimming pools are also heated geothermally; even the tiniest of villages has one. Iceland must hold the world record for the ratio of people to pools. Indeed, one of the oldest relics of ancient Iceland is a bathhouse. Snorralaug in Reykholt was commissioned by Snorri Sturluson around 800 years ago. He supposedly came here to hold council with his trusty followers – there's room for twelve of them – and hatch out the more brilliant of his many ideas.

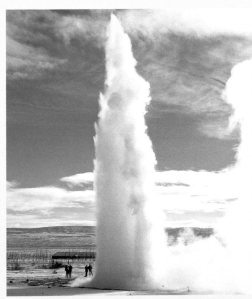

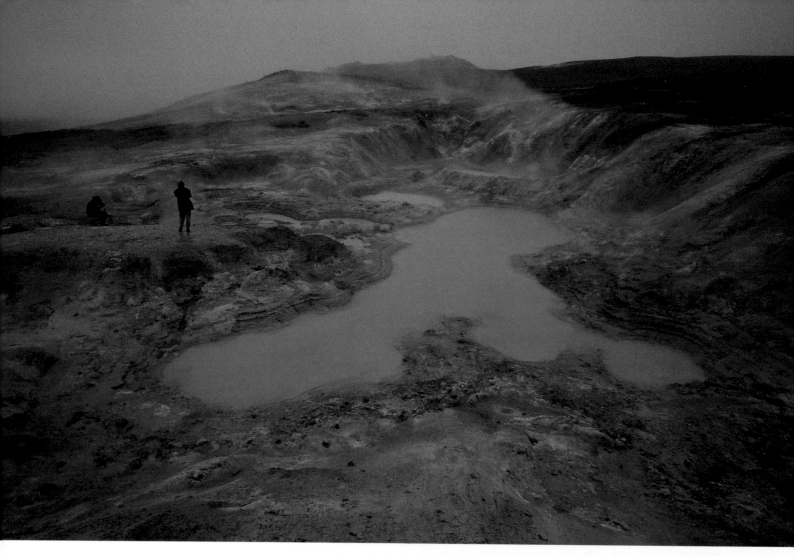

One of the most fascinating by-products of Mount Krafla are its mudpots and mudholes which menacingly bubble, whistle and hiss. Standing here is literally like sitting on top of a volcano – one which could explode at any minute.

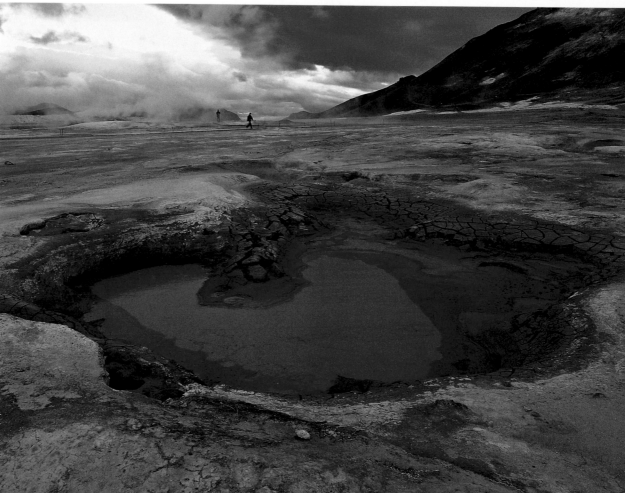

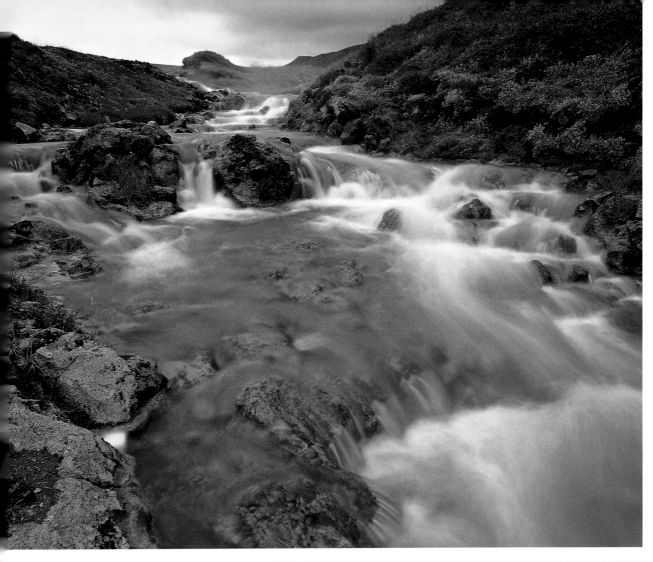

Left:
Although much of the energy has been extracted from the hot springs at the Krafla power plant the water is still warm. It's heated by a magma chamber three to seven kilometres (two to four miles) beneath the earth's surface.

Below:
The Hverfjall Crater, created around 2,500 years go, is encircled by a ring of volcanic ash. The rather laborious climb to the top is rewarded by intriguing views down 150 metres (492 feet) into the crater which measures around one kilometre (half a mile) across.

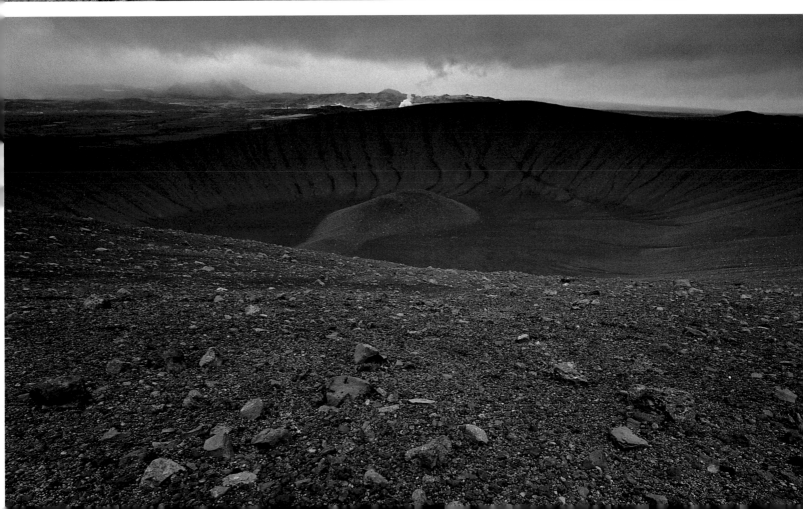

Top and bottom right:
At the Seyðisfjörður ferry terminal. The tiny harbour town on the fjord of the same name in the east of the country is where visitors travelling from the European Continent – via the Faroe Islands – first set foot on volcanic Icelandic soil. Over 100 years ago Seyðisfjörður was a busy centre of the herring industry dominated by Norwegians, who have left their distinctive mark on the port.

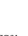

Right page:
With a population of ca. 15,000 Akureyri is the second-largest city on the island and – thanks to its university – the academic hub of the north. Founded by settler Helgi Magri in the 9th century, during the short summer nights of June and July the town at the end of Eyjafjörður positively hums.

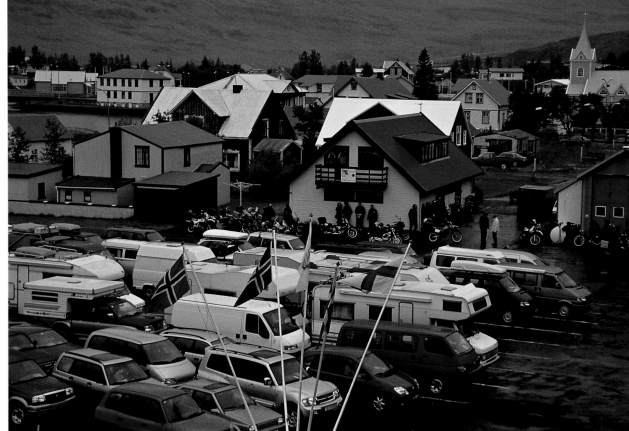

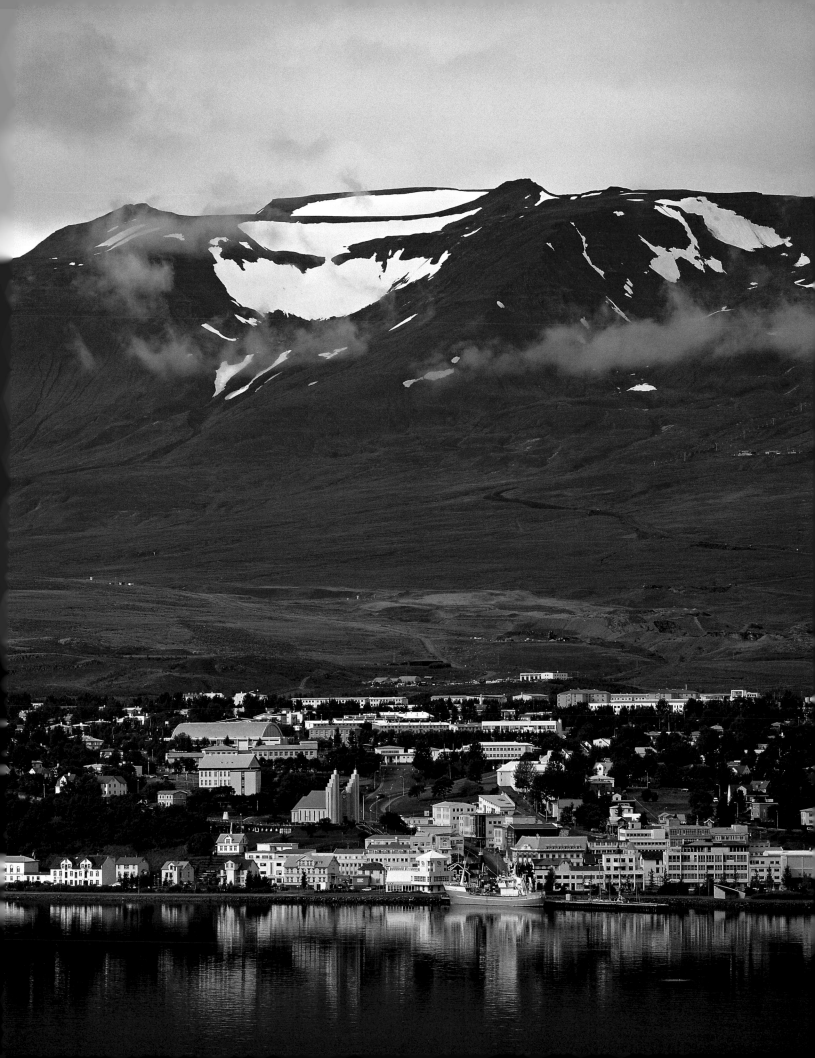

Above:
A winter's evening on
Reyðarfjörður, the longest
fjord in the east of the
country (30 kilometres/18
miles long). The »Land-
námabók« tells of the first
settlers who landed here
in lieu of the Faroe Islands
– where they were orig-
inally headed – during
the 9th century.

Right:
An abandoned farm on
Fáskrúdsfjörður in the
east is part of the fishing
village of the same name.
In the background the
island of Skrúður looms
sombrely against the grey
sky, home to Iceland's
largest colony of herring
gulls.

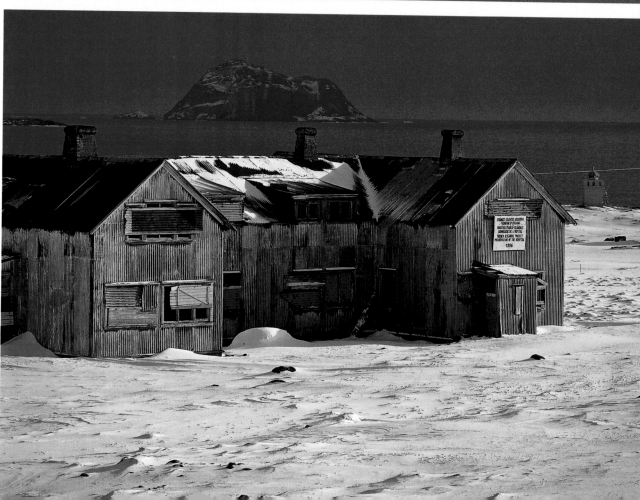

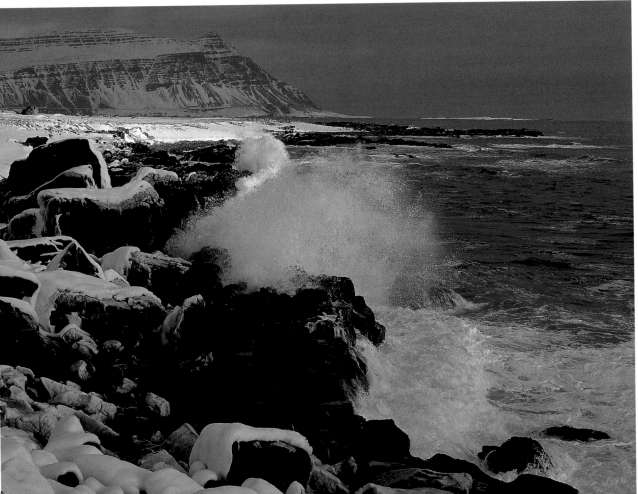

Left:
The coast on Fáskrúds-
fjörður. Further inland
the fjord is lined with tall,
lava-capped mountains;
these gradually disappear
the nearer you get to the
sea. Fáskrúdsfjörður also
has one of Iceland's ex-
tremely rare expanses of
forest.

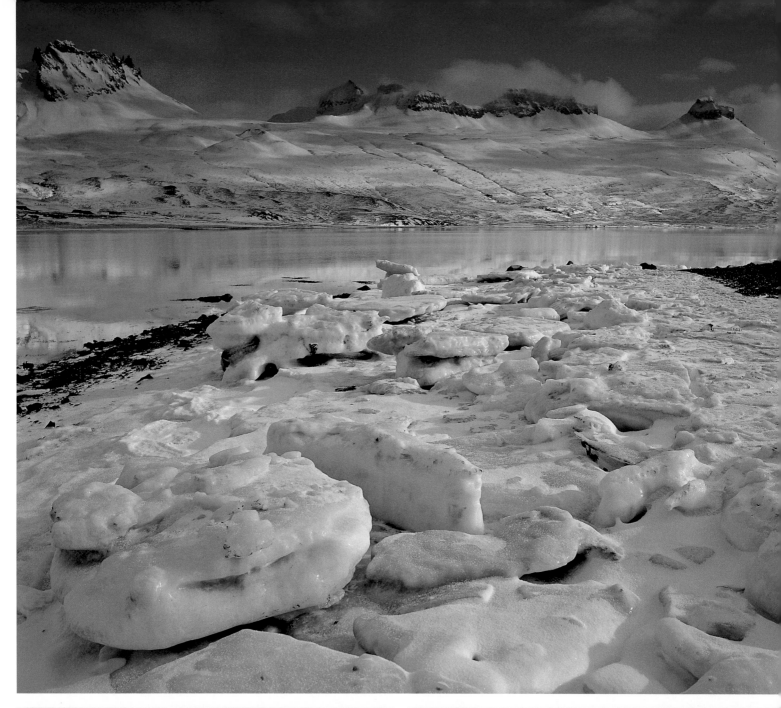

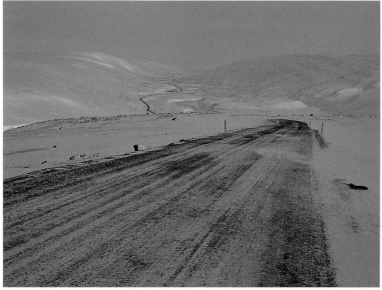

eft:
rufjörður in winter. The
ow melts quickly here;
e many hours of sun-
ine and black sand en-
re that the temperature
oesn't stay low for long.

**Left page, bottom left
and right:**
The roads in the east of
Iceland are deserted in
the dead of winter, braved

only by those with suitable
vehicles. Here, an intrepid
traveller on the Ring Road
outside Egilsstaðir.

Below:
Farmstead on Reyðar-
fjörður. People feel the
isolation of the Icelandic
countryside most keenly
during the winter months,

running up huge telephone
bills and consuming con-
siderable amounts of the
country's extortionately
priced alcohol.

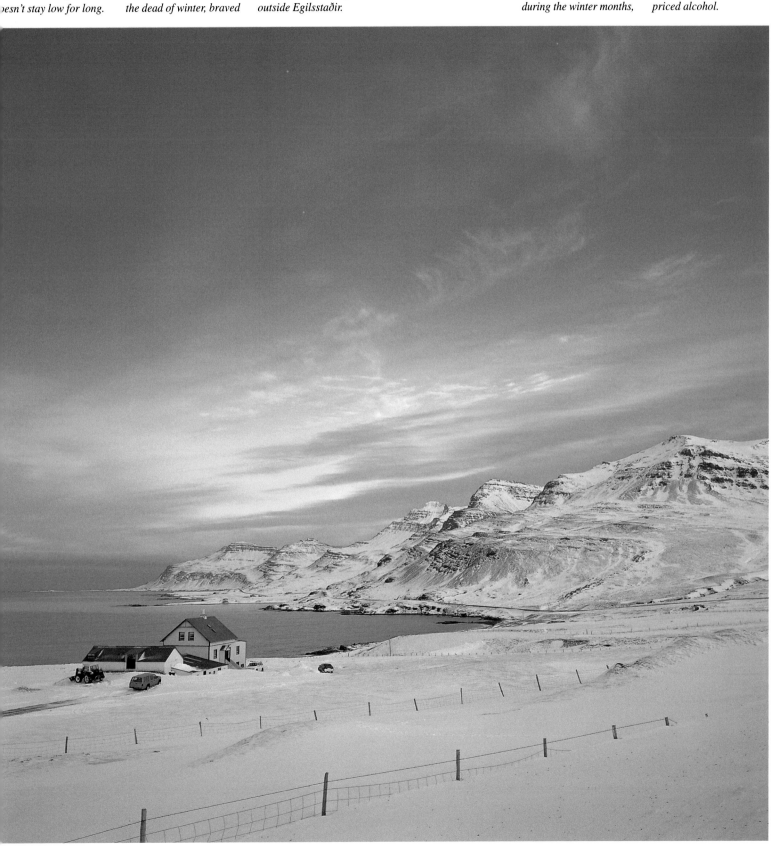

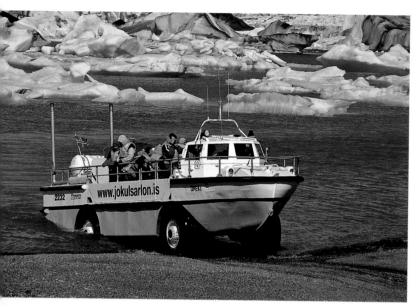

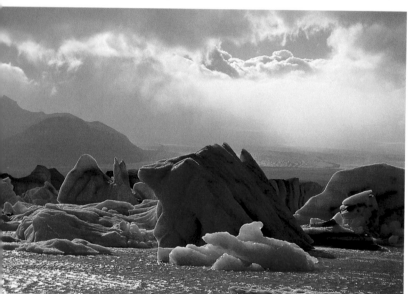

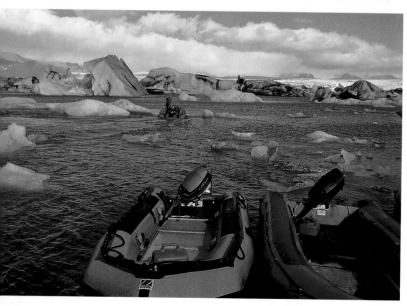

Top left:
One of the highlights
of any trip to Iceland is
a ride in an amphibious
vehicle to the icebergs
of Jökulsárlón.

Centre left:
The icebergs drifting
across the surface of
Jökulsárlón glacial lake
are a breathtaking spec-
tacle, brought within
reach aboard the right
form of transport.

Bottom left:
In case of emergencies th
Jökulsárlón vehicles hav
lifeboats in tow. Should
anyone fall overboard,
they must be pulled out
of the icy water as quickl
as possible.

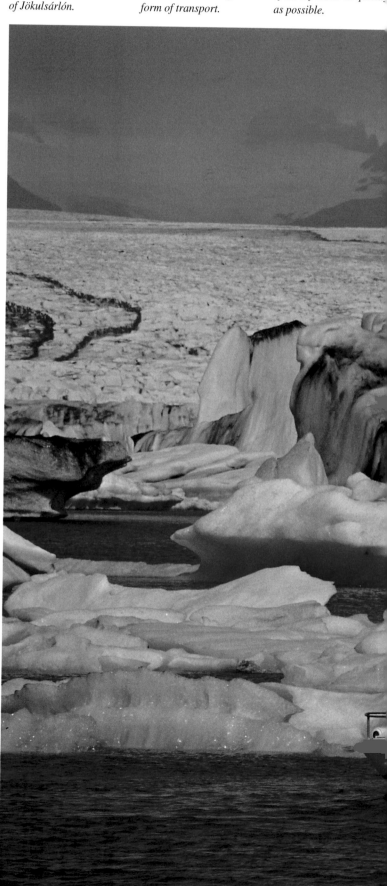

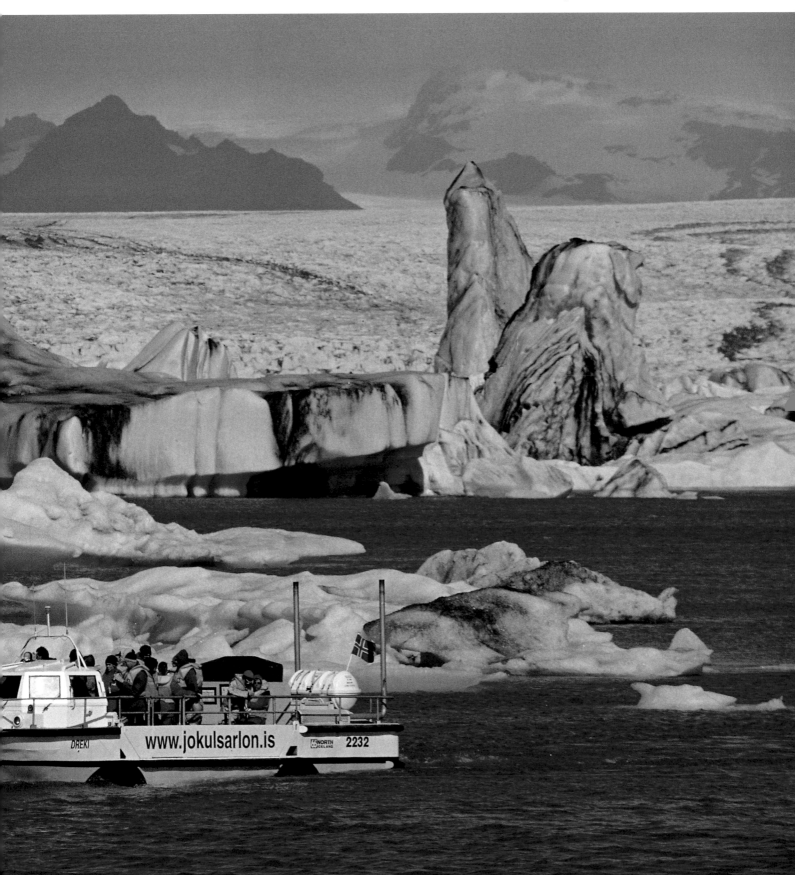

Below:
Sailing past the icebergs
of Jökulsárlón is a feast
for the eyes, with the ice
gleaming white, green,
blue and even black in the
northern light.

DREKI

www.jokulsarlon.is

NORTH
ICELAND

2232

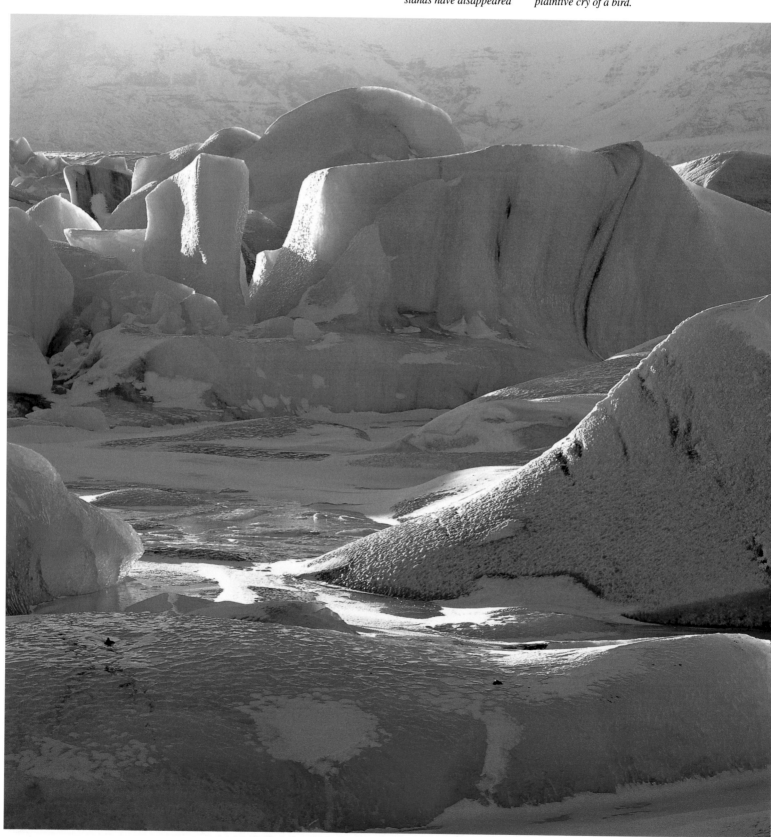

The loneliness of winter on Jökulsárlón. The restaurant and snack bar are closed, the souvenir stands have disappeared and there's not a car in sight on the nearby road. The icy silence is only broken by the occasional plaintive cry of a bird.

*Vatnajökull in the back-
ground supplies several
glacial lakes with mag-
nificent icebergs. The
sandur or sand desert of
Breiðamerkursandur*
*boasts a number of them
on the lakes of Fjallsárlón,
Breiðárlón, Stemmulón
and, most famously,
Jökulsárlón.*

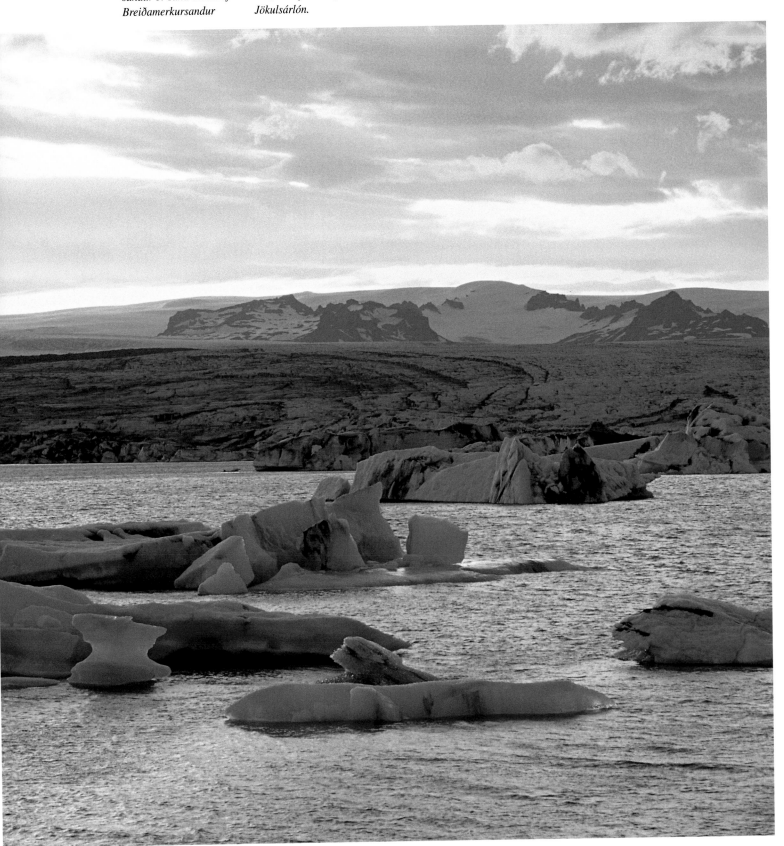

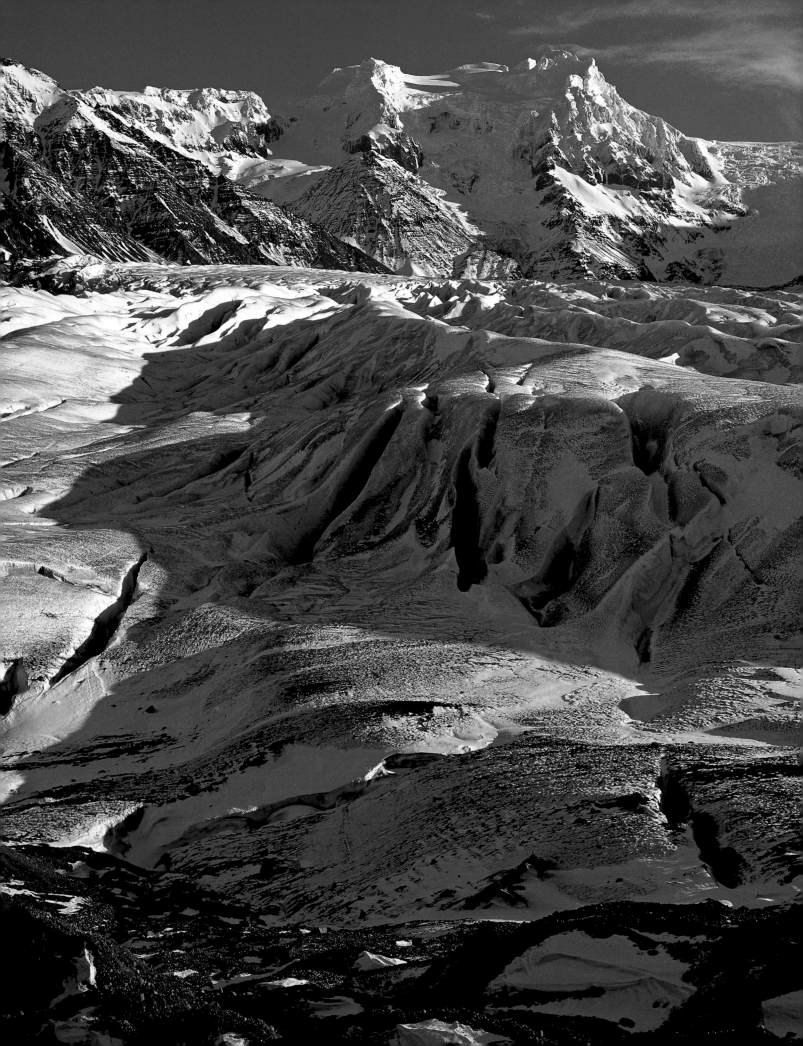

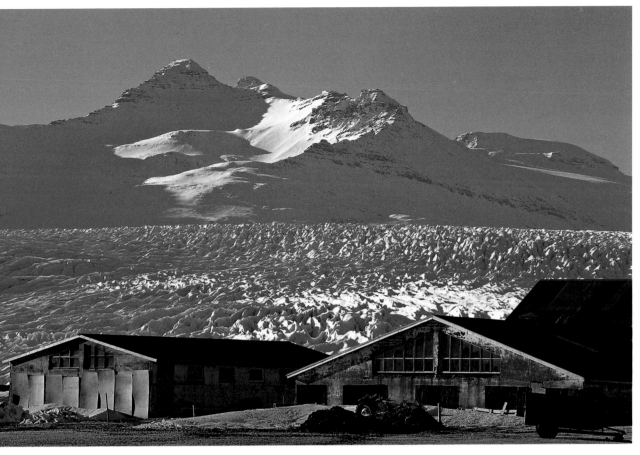

Made Iceland's second-largest nature conservation area in 1967, one of the prime features of the Skaftafell National Park is the impressive Svinafellsjökull Glacier. The park also has waterfalls, banks of moraine, raging rivers, forests of birch and rowan and the highest mountain in the land, the Hvannadalshnúkur.

The glacial tip of the Fláajökull stretches right down into the valley, with Raudaberg Farm just in front of it.

Skeiðarársandur is the name of the sandur in the southeast of the country, 30 kilometres (18 miles) long and 20 kilometres (12 miles) wide. Frequent jökulhaups or floods of meltwater caused by the Grímsvötn Volcano have placed Skeiðarársandur firmly on the map, with a monument erected to commemorate the area's last natural catastrophe.

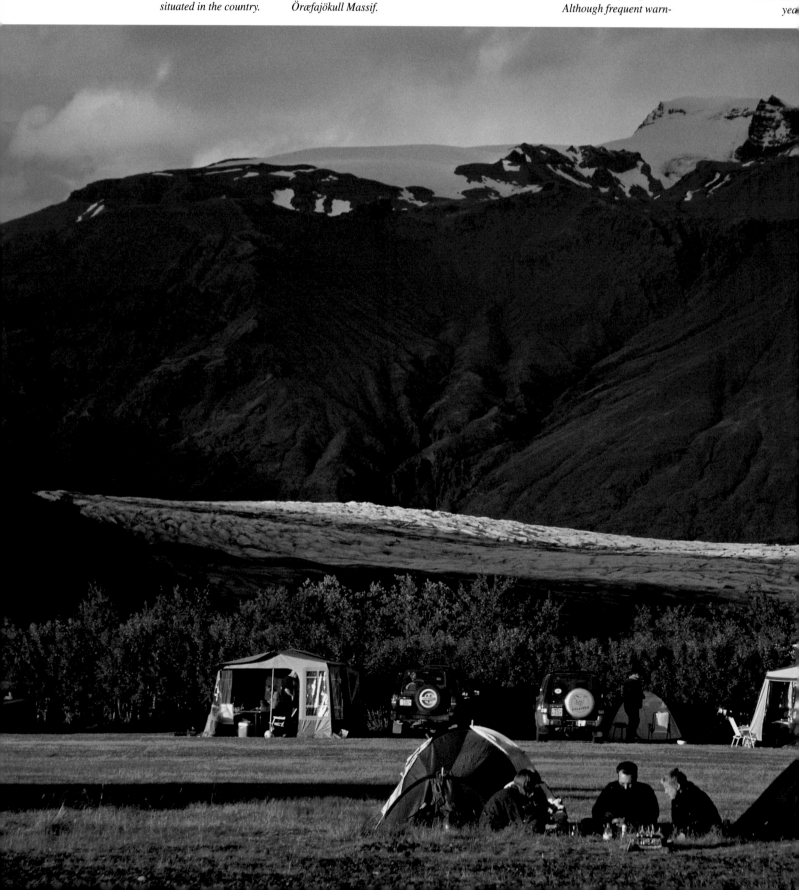

Below:
The camp site in Skaftafell National park is one of the best equipped and also the most impressively situated in the country.

Here travellers camp in the shadow of the Hvannadalshnúkur, the 2,119-metre (6,952-foot) mountain belonging to the Öræfajökull Massif.

Top right:
One of the frozen foothills of the Vatnajökull, Europe's largest glacier. Although frequent warn-

ings are issued not t underestimate the dange of this winter wonderlan accidents still occur eve yea

Centre right:
Touring by bike is a great
way to get really close to
nature in Iceland. However,
cyclists need to be well

equipped, fit and able to
concentrate when negoti-
ating Iceland's many rough
sand and dirt tracks.

Bottom right:
On the Vatnajökull. The
best way to travel around
the glacier is by snow
mobile – with an experi-
enced guide at the helm.

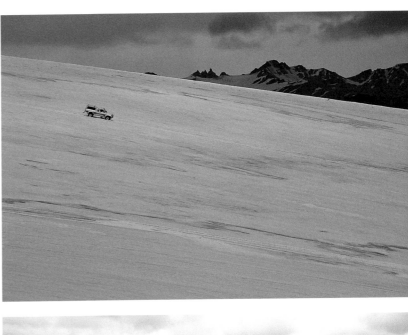

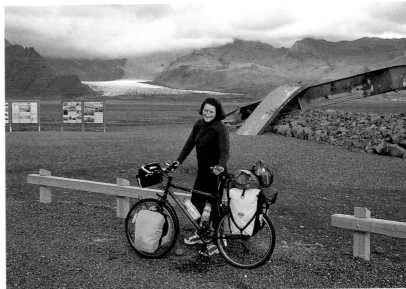

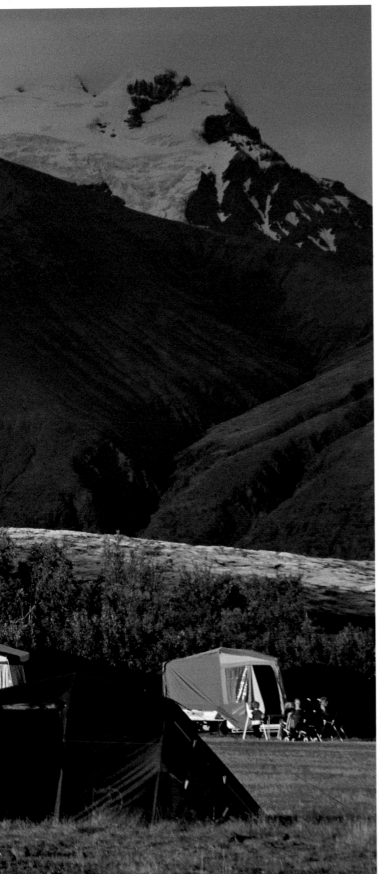

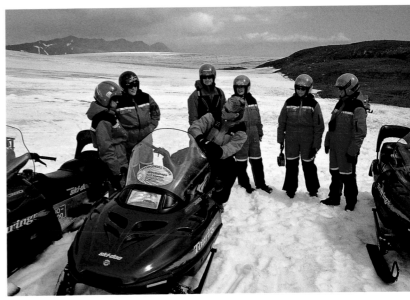

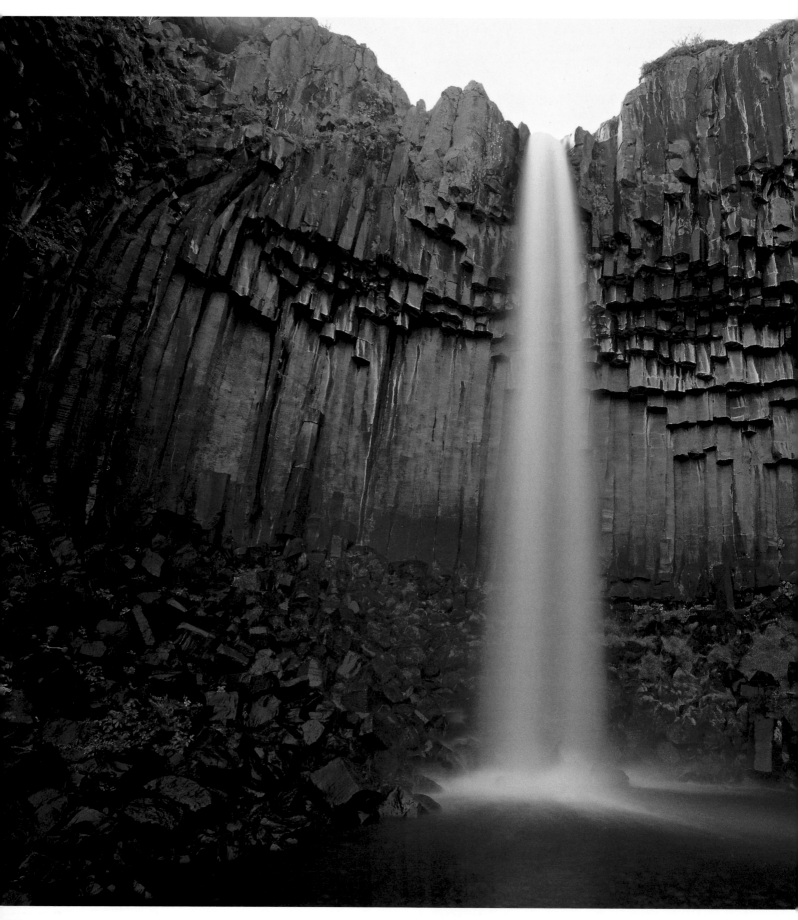

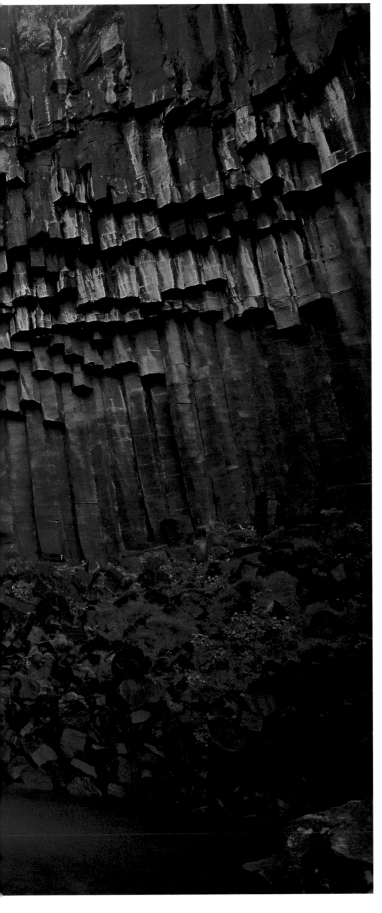

It's a short trek from the campground in Skaftafell National Park to Svartifoss, a huge waterfall tumbling down a solid wall of basalt, its regular formations like the pipes on a church organ. A green ring of moss and ferns surrounds the clear pool, its surface broken by stumps of rock jutting up from the depths.

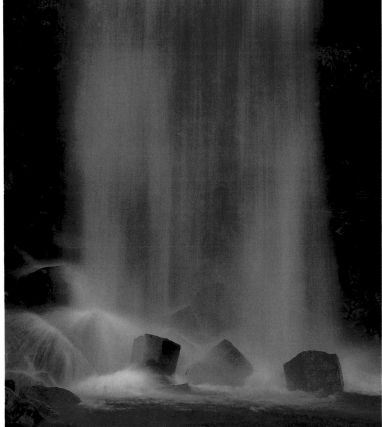

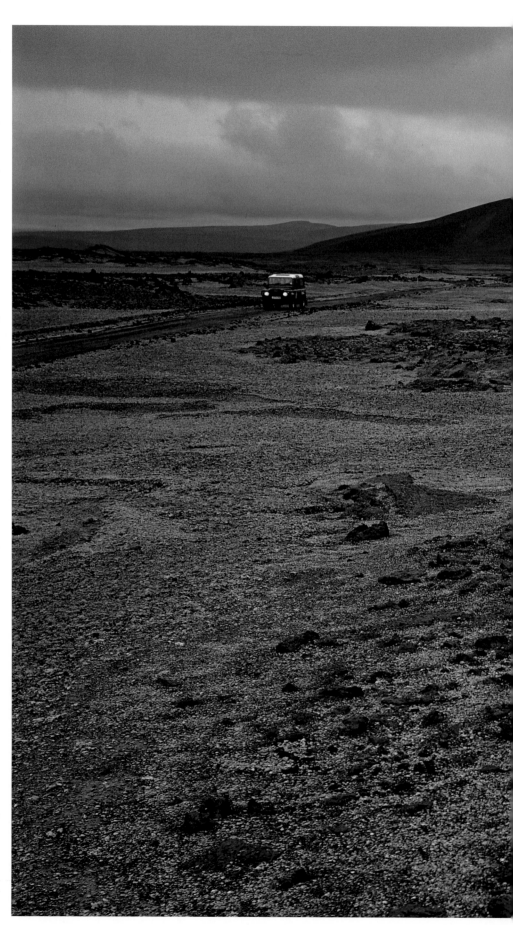

*Ódáðahraun, »the desert
of the wrongdoers«, is
Iceland's largest lava
field. It was formed when
rivers of lava from several
eruptions collided and
solidified, covering an area
of 4,500 square kilometres
(1,737 square miles). For
centuries this barren wil-
derness provided outlaws
with a place of refuge,
hoping to escape punish-
ment or even death at the
hands of their pursuers.*

The term »highlands« is a bit of
an anomaly, for Iceland's high-lying terrain
is not so much distinguished by its bevy of
precipitous peaks as by its lack of human
inhabitants. Over half of the population live
in Reykjavík, with the rest dotted along the
coast around the island. Inland Iceland,
totally inhospitable, is practically deserted.

In the past hardly anybody ventured out
into the highlands unless they had to. It was a
place of refuge for outlaws only. Ódáðahraun,
the largest lava field in the country, is thus
aptly subtitled »the desert of the wrongdoers«.
The most famous Ódáðahraun fugitive was
Fjalla-Eyvindur, who in the 18th century
managed to survive for two decades in this
infinite, miserable, barren wilderness north
of Vatnajökull.

The not insignificant number of visitors
intrepid enough to brave the highlands do so
for other reasons. They come here to be at
one with nature, to bask in the absolute soli-
tude and satisfy their spirit of adventure.
And even if nowadays the torturous routes
– somewhat innocently defined as »trails« –
are tackled by jeep or customised off-road
bus, the journey is no less perilous.

There are two classic highland tours to
choose from. The Sprengisandur Route
follows an ancient trail from the time of the
sagas, linking the southwest and northeast of
the country. The highlight and namesake
of the trip is the lunar desert which covers
200 square kilometres (77 square miles). The
Kjölur Route is marked by the enormous
Hvítárvatn glacial lake and the hot springs of
Hveravellir.

THE HIGHLANDS

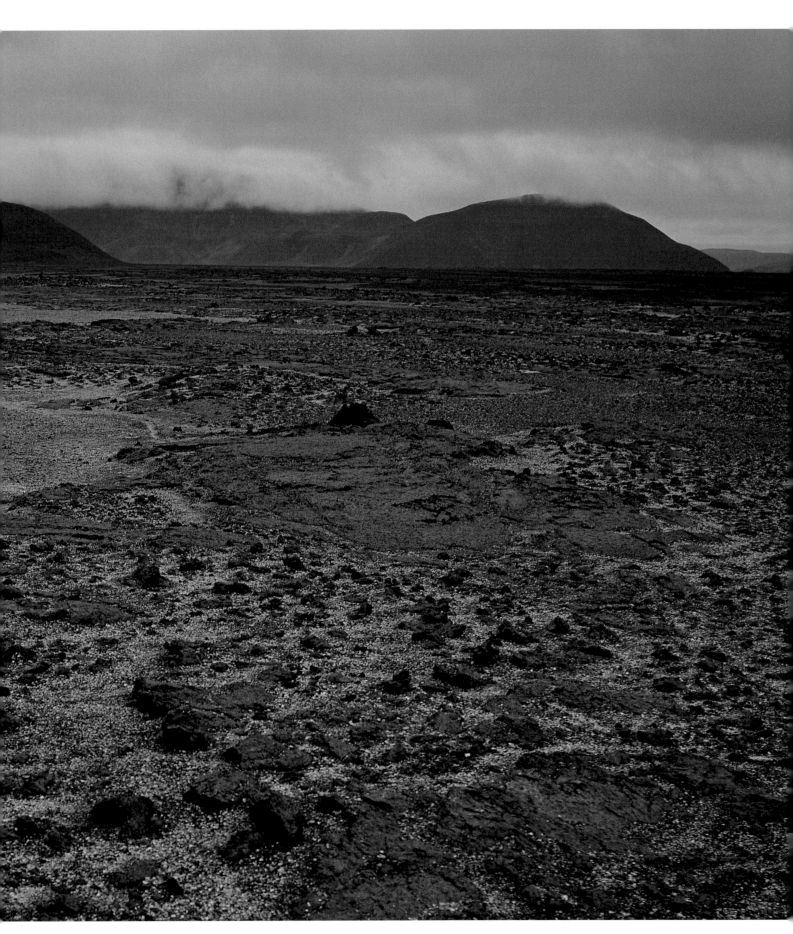

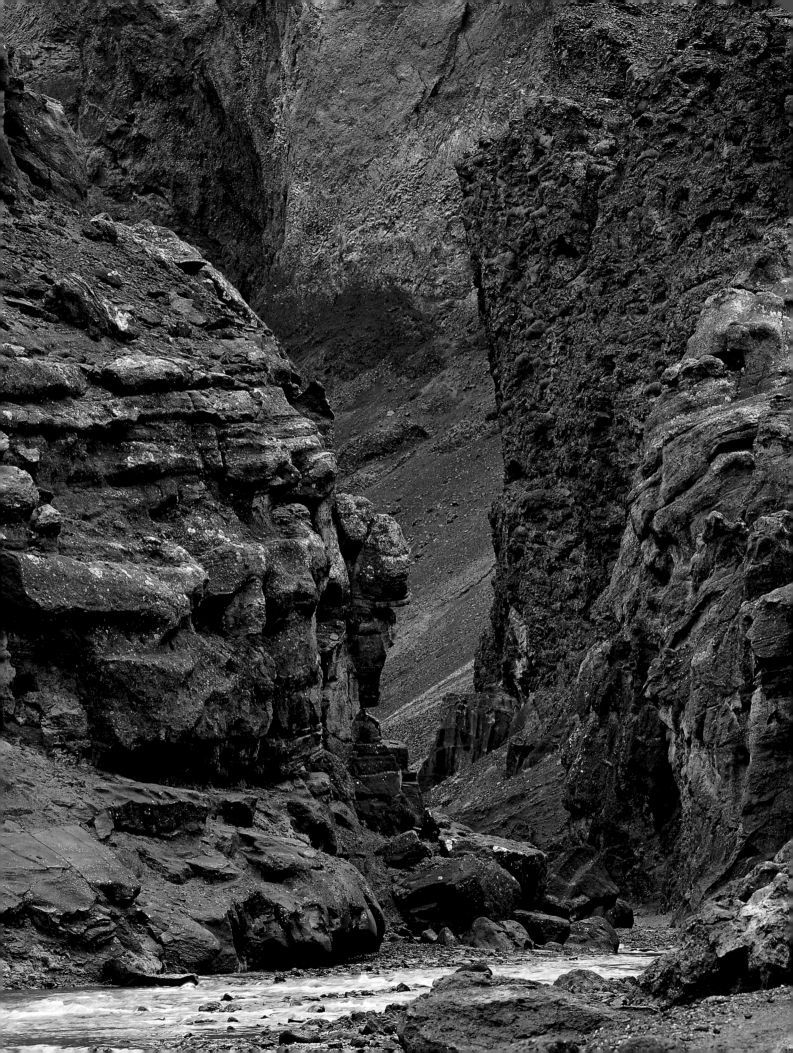

ft page:
rge near Askja, an ormous caldera in the elandic highlands. Un- e the coast the country

inland has remained largely uninhabited. Access is provided by a handful of trails and dirt tracks.

Below:
The journey to Askja involves negotiating deserts of lava, deep ravines, fields of tephra and precipitous mountains, not to mention the occasional river or small lake.

Below:
Iceland has an excellent network of buses which can easily navigate their way through the rocky highlands. The mountainous slope leading up to

Hveravellir, one of the largest geothermal areas in the country, is part of the Kjölur Route which is opened at the beginning of July.

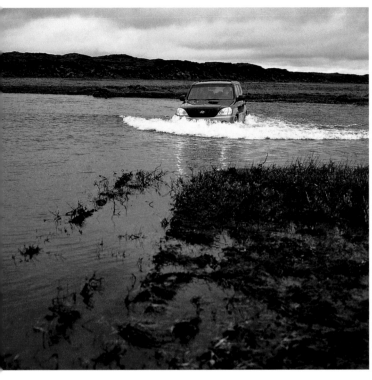

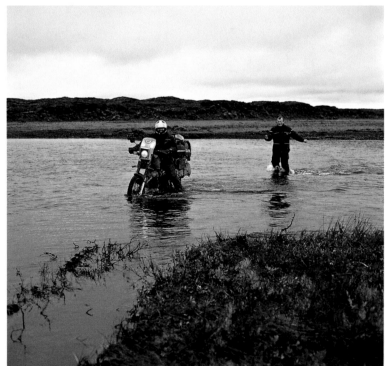

bove:
gnposts in the middle of where. Between the two aciers Vatnajökull and ofsjökull are 200 square

kilometres (77 square miles) of lava and sand desert known as Sprengisandur. Crossing

this area is one of the great highlights of the legendary Sprengisandur Route.

Above:
Off-road motorbikes are an increasingly common occurrence on the highland routes of Iceland.

What starts out as a great adventure can, however, end in tragedy if your trusty steed breaks down.

It's thus advisable to travel in convoy so that you always have help to hand should you need it.

The Jökulsá á Fjöllum River, the second-longest in the country, rises in the northern Vatnajökull. It collects water from streams and rivers across an area of 8,000 square kilometres (3,089 square miles) and is also fed by several waterfalls on its route to the sea.

In 1875 the enormous Askja Caldera was joined by a second, much smaller version, the Víti or Crater of Hell, now filled with warm water. Öskjuvatn Lake next to it, Iceland's deepest, was also created by Víti erupting. Here the water is freezing cold.

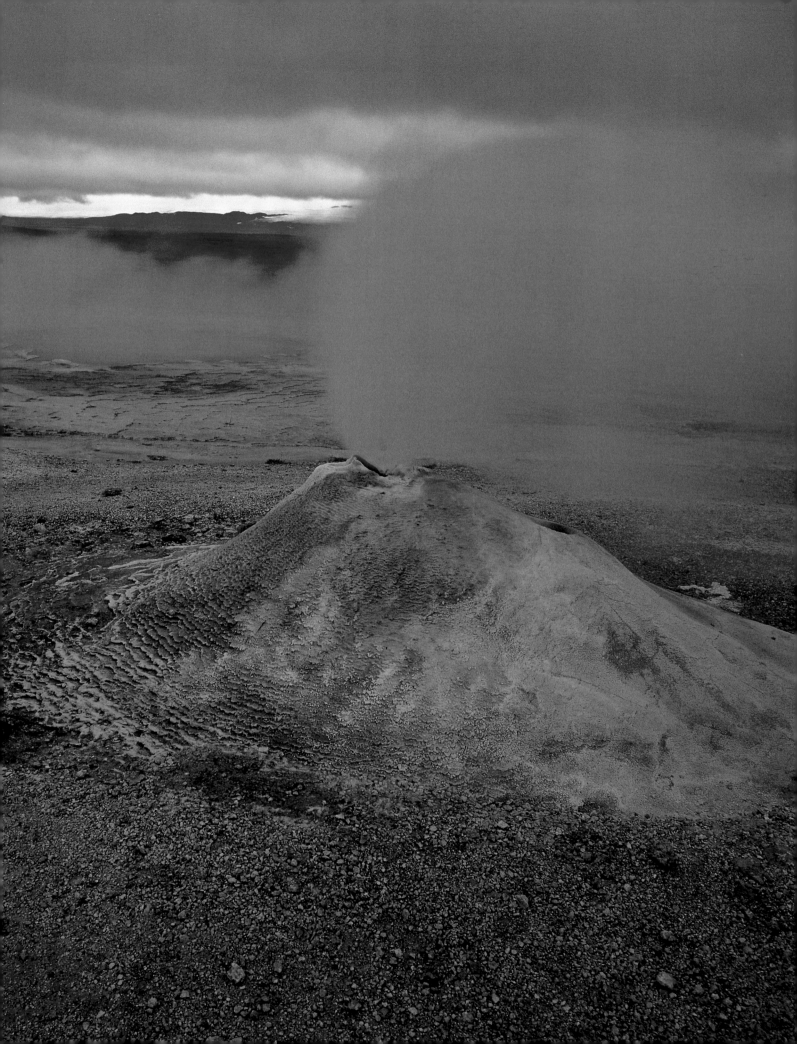

eft page:
he hot springs of
Iveravellir enabled
jalla-Eyvindur, probably
:eland's most infamous
utlaw, to survive

20 years in the wilder-
ness. He lived in a crevice
in the lava and fed off
the meat of rustled sheep
and cattle and the plant
angelica.

Below left and right:
Next to the old mountain
hut at Hveravellir, heated
by geothermal energy,
is a pool full of hot water
where hikers can take a
well-earned rest.

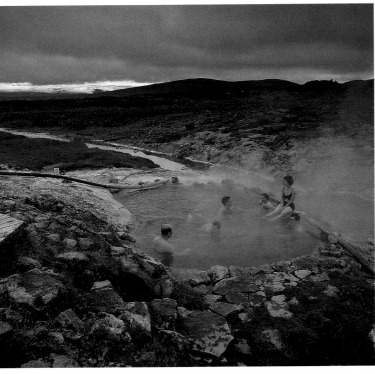

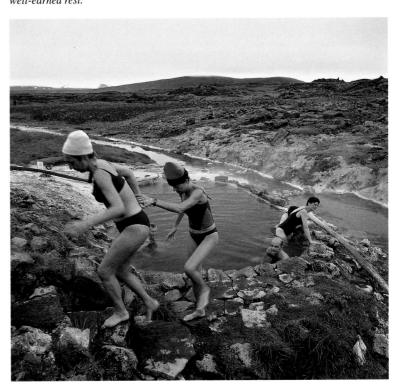

Above:
Hveravellir is one of the
most spectacular spots
in the highlands and
serviced by local buses,

making it rather busy.
Things calm down
towards evening when the
last bus-loads of tourists
have departed.

Above:
The hot springs are not
only audibly impressive,
with water and steam
hissing and bubbling as

they escape from the
ground, but also visibly
pleasing with colourful
sinter deposits.

Riverine landscape near Landmannalaugar. The »warm springs of the land men« are near a legendary highland trail.

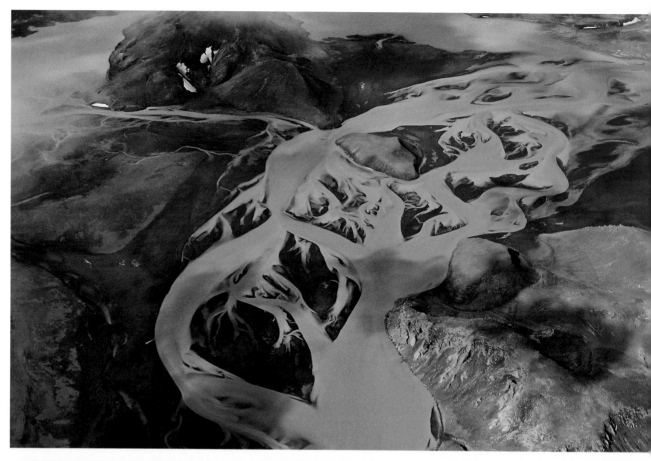

The mountains surrounding Landmannalaugar are famous for their fantastic colouring. This is due to the high percentage of rhyolite or solidified acid lava contained in the rock, which depending on the light and humidity levels glows either red, brown, yellow or green.

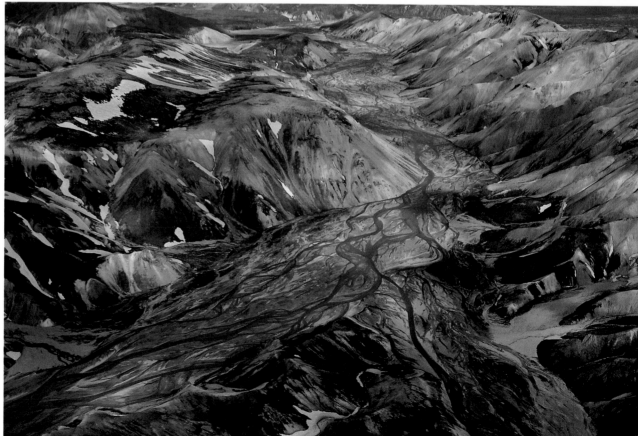

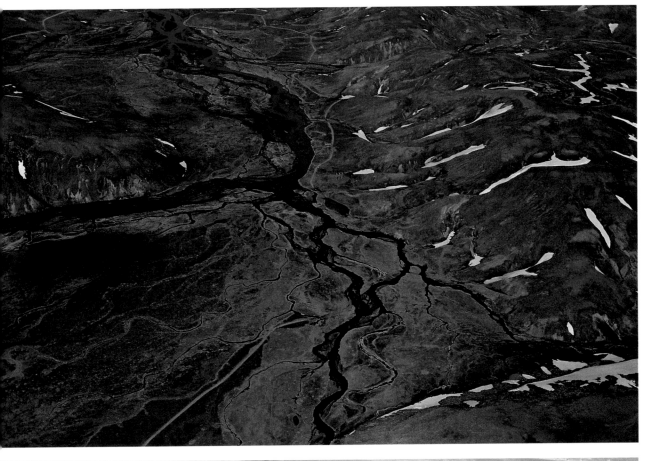

This aerial photograph shows the section of lunar landscape between Landmannalaugar and Eldgjá (Fire Gorge), at 30 kilometres (18 miles) long the largest volcanic rift in the world.

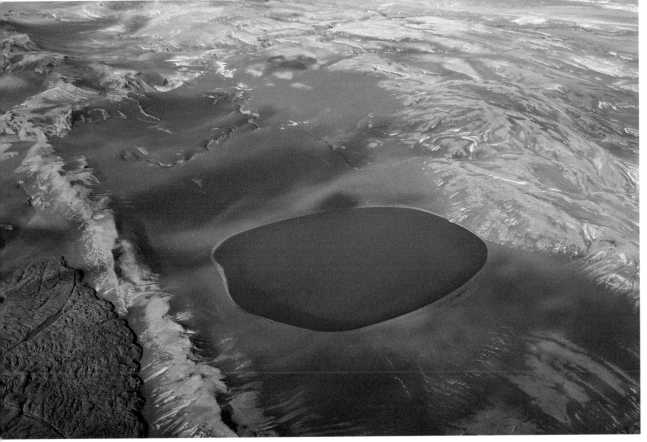

East of Landmannalaugar the peaks of the Hekla Massif rise 1,500 metres (4,900 feet) up into the sky. The most active volcano on the island is also the most dangerous, its rivers of red-hot lava destroying everything in their path. The brilliant blue maar at the foot of the smoking monster is also the product of volcanic activity.

Page 120/121:
Enjoying the hot water springs of Landmannalaugar, one of the country's many natural swimming pools.

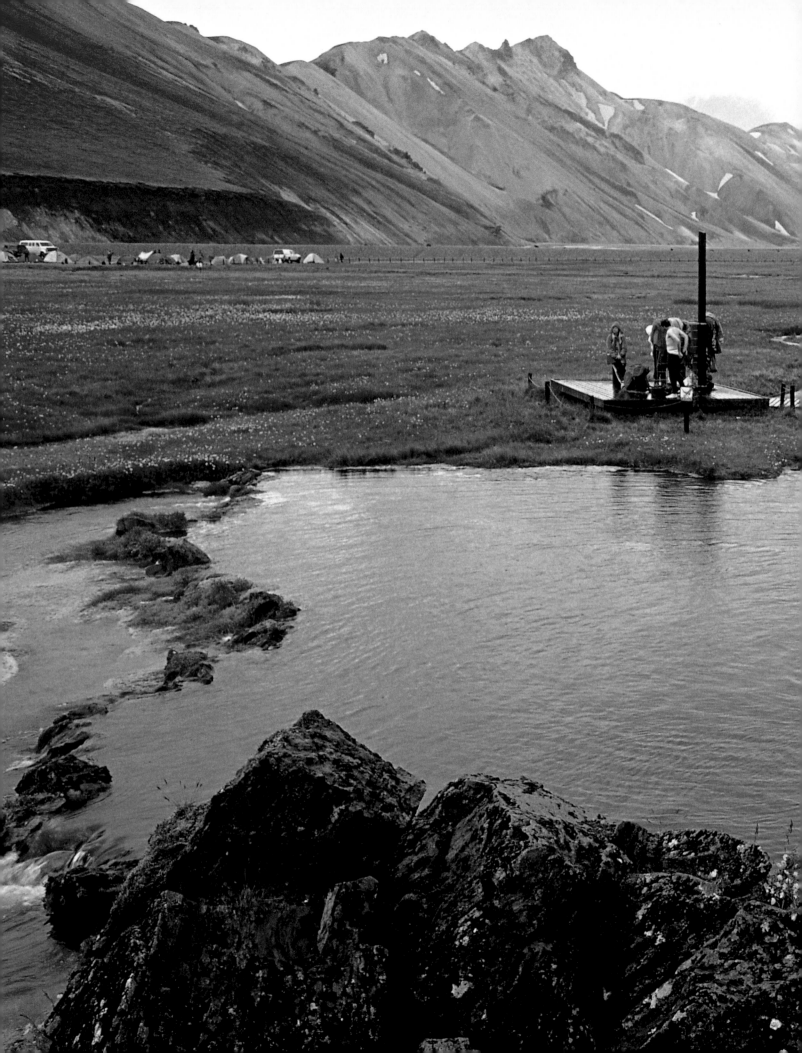

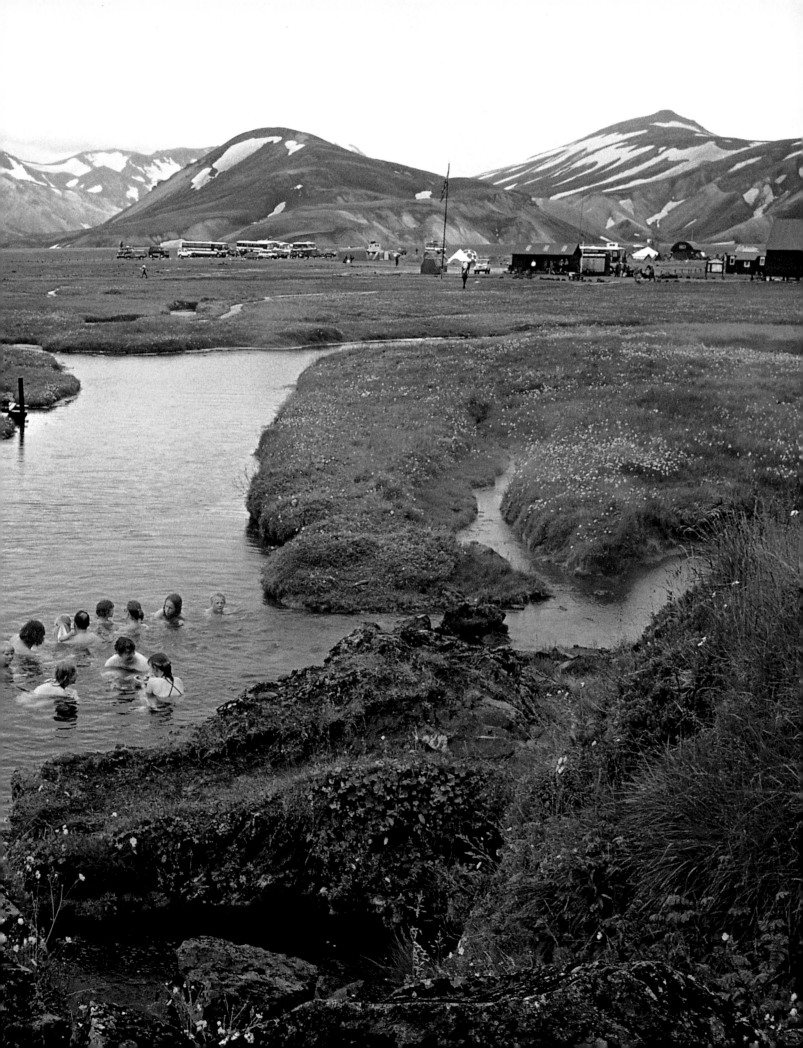

INDEX

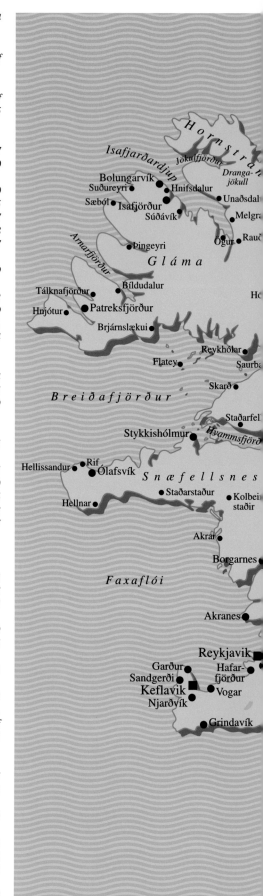

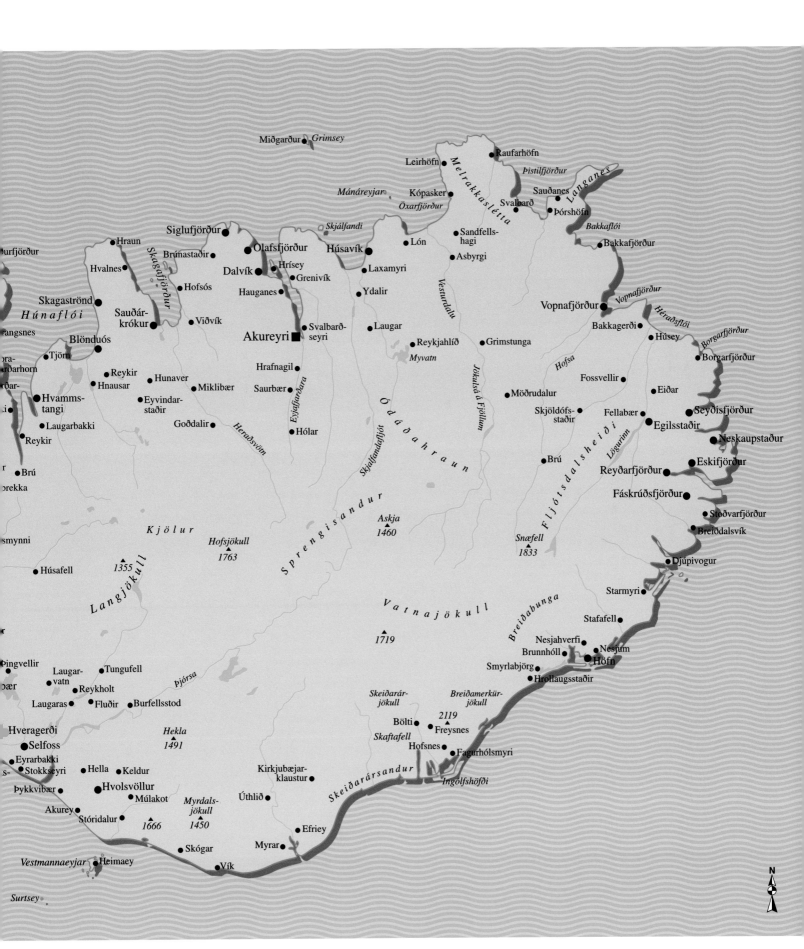

Miðgarður · *Grimsey*

Leirhöfn · Raufarhöfn

Melrakkaslétta

Þistilfjörður

Mánáreyjar Kópasker Saudanes *Langanes*

Öxarfjörður Svalbarð

Þórshöfn

Siglufjörður *Skjálfandi* Sandfells- *Bakkaflói*

Hraun hagi Bakkafjörður

Skagafjörður Ólafsfjörður Húsavík Lón

Brúnastaðir Hrísey Asbyrgi

Hvalnes Dalvík Grenivík Laxamyri

Hofsós Haugganes Ydalir *Vesturdalu*

Skagaströnd Viðvík Vopnafjörður *Vopnafjörður*

Húnaflói Saudár- *Héradsflói*

krókur Svalbarð- Laugar Bakkagerði

angsnes Blönduós Akureyri seyri Reykjahlíð Grimstunga Húsey *Borgarfjörður*

ra- Tjörn *Myvatn* *Hofsa* Borgarfjörður

arðarhorn Reykir Hrafnagil Fossvellir Eiðar

röar- Hnausar Hunaver Miklibær Saurbær Möðrudalur Fellabær Seyðisfjörður

.i Hvamms- Eyvindar- Skjöldólfs- Egilsstaðir

tangi stadir *Héradsvötn* staðir Neskaupstaður

Laugarbakki Goðdalir *Ó d á ð a h r a u n* Brú Eskifjörður

Reykir Hólar Reyðarfjörður

Skjálfandafljöt *Flji óts dalsheiði*

r Brú Fáskrúðsfjörður

orekka

Snæfell Stöðvarfjörður

Kjölur *Askja* *1833* Breiðdalsvík

smynni *Hofsjökull* 1460

1763 *Sprengisandur* Djúpivogur

Húsafell *1355* Starmyri

Langjökull *Vatnajökull* *Breiðabunga* Stafafell

Pingvellir 1719 Nesjahverfi

bær Laugar- Tungufell Brunnhóll Nesjum

vatn *Þjórsá* Smyrlabjörg Höfn

Laugaras Reykholt Hrollaugsstaðir

Fluðir Burfellsstod *Skeiðarár- Breiðamerkür-*

jökull jökull

Hveragerði *2119*

Selfoss *Hekla* Bölti Freysnes

Eyrarbakki *1491* *Skaftafell* Hofsnes

s- Stokkseyri Hella Keldur Kirkjubæjar- Fagurhólsmyri

Pykkvibær Hvolsvöllur klaustur *Ingólfshöfði*

Akurey Múlakot Úthlið *Skeiðarársandur*

Stóridalur *Myrdals-*

1666 *jökull* Efriey

1450

Skógar Myrar

Vestmannaeyjar Heimaey Vík

Surtsey

N

A trip across Lake Jökulsárlón with its glittering blue icebergs is an absolutely fascinating experience.

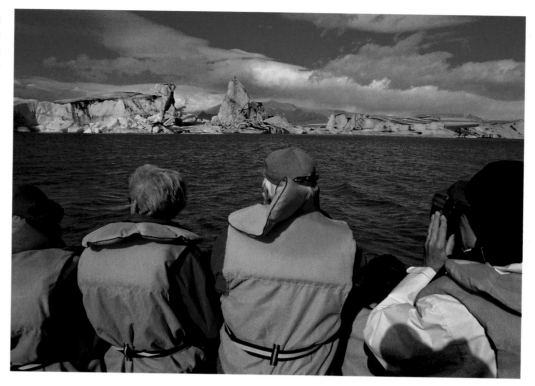

Credits

Design
hoyerdesign grafik gmbh, Freiburg

Map
Fischer Kartografie, Fürstenfeldbruck

Translation
Ruth Chitty, Schweppenhausen

Printed in Germany
Repro by Artilitho, Trento, Italy
Printed and bound by Offizin Andersen Nexö, Leipzig
© 2004 Verlagshaus Würzburg GmbH & Co. KG
© Photos: Max Galli

ISBN 3-8003-1609-9

Stürtz